LIVERPOOL'S RAILWAYS

THROUGH TIME

Hugh Hollinghurst

D1579415

Acknowledgements

To the Liverpool Record Office and especially Roger Hull for their help and use of archive photos on the following pages: 6, 8, 9, 11, 12, 14, 15, 17, 18 (2), 19, 26 (2), 27, 31, 45 (British Railways Board), 48, 49, 60, 61, 64, 72, 86, 87, 92, 96.

To the Sefton Library Service and especially Dave Ewing and the Local History section at Crosby Library for their help and use of archive photos on the following pages: back cover, 16, 29, 34, 39 (2), 40, 44, 50, 51 (2), 52, 56, 57, 59, 63, 76, 88 (2), 89.

Credits to Alex Appleton photograph, copyright Industrial Railway Society: 68; Zorina Barrett: 24 (inset); John H. Bird/Southern-Images.co.uk: front cover (upper), 10 (lower); Ben Brooksbank© Copyright and licensed for reuse under this Creative Commons Licence: 33, 38; Crosby and District Historical Society: 35, 41; The Engineer: 72; Graeme Gleaves (Coventry Electric Railway Museum): 42, 74; Roger Golder archive photos: 13, 21, 22 (2), 23 (2), 24 (2), 25 (inset), 30, 31, 32, 41 (inset), 42 (lower), 46, 47 (2), 53, 54, 55, 62, 70, 93, 94, 95; Ray and Margaret Harley: 58; Albert Hawarth: 37; Hugh Hollinghurst: all other modern photos; Paul Hollinghurst: front cover (lower),14, 15, 19, 21, 28 (lower), 40, 41, 43 (2), 44 (inset), 49 (inset), 53, 54 (lower), 59, 67, 71 (inset), 72, 74 (2), 91 (lower), 92 (inset), 94 (inset), 95, 96; P. Kerwin: 20 (lower); Peter Levick: 73, 85; Manchester Archives and Local Studies: 10;Merseyrail: 8, 31, 43 (inset); D. J. Norton: 75, 77, 78, 79, 80, 81, 82, 83, 84, 90 (lower); Online Transport Archive: 7 (2) (Charles Roberts), 25 (E. V. Richards), 25 (Brian Faragher); Peter Owen: 36, 41; Jim Peden photographs, copyright Industrial Railway Society: 66, 67 (2), 68, 69 (2), 70, 71, 78 (inset), 79 (inset), 86 (lower), 87(lower), 93 (inset); Ribble Steam Archives: 68, 70 (inset); Pat Thomas: 60 (lower); Mike Treanor: 80 (lower); Trinity Mirror: 34; Bill Turpin: 76.

To Jonathan Cadwallader and Peter Levick, who have helped me in my research, and John Quirk, who has also proofread the text.

To the following publications:

Paul Anderson: An Illustrated History of Liverpool's Railways.
Paul Bolger: The Docker's Umbrella.
John W Gahan: Line Beneath the Liners; Rails to Port and Starboard; Seaport to Seaside; Seventeen Stations to Dingle.

Above all to my wife Joan who has proofread and been a great source of encouragement and an example of patience and understanding.

First published 2015

Amberley Publishing
The Hill, Stroud, Gloucestershire, GL5 4EP
www.amberley-books.com

Copyright © Hugh Hollinghurst, 2015

The right of Hugh Hollinghurst to be identified as the Author of this work has been asserted in accordance with the Copyrights, Designs and Patents Act 1988.

ISBN 978 1 4456 4496 7 (print)
ISBN 978 1 4456 4516 2 (ebook)

British Library Cataloguing in Publication Data.
A catalogue record for this book is available from the British Library.

Typesetting by Amberley Publishing.
Printed in Great Britain.

Introduction

The Liverpool and Manchester Railway opened in 1830 and was the first 'inter-city' line in the world, carrying both passenger and freight traffic and hauled by steam. The preceding year had witnessed a key event in the industrial revolution when trials were held in nearby Rainhill to consider the feasibility of steam power. The competition was won by George Stephenson's *Rocket*, the prototype of standard steam locomotive design ever since. The opening of the line, a national event, was marred by the first widely reported death in a railway accident. One of Liverpool's two MPs, William Huskisson, was mown down by the *Rocket* when he was attempting to heal a quarrel with the then Prime Minister, the Duke of Wellington. The locomotives finished their run at a gateway to Liverpool formed by a Moorish Arch designed by the eminent Liverpool architect John Foster Junior near Edge Hill. From that point, cable-hauled trains were hauled through tunnels to two termini: one up to a passenger terminus at Crown Street and a second one down to a goods terminus at Wapping. Crown Street became a goods yard when the line was extended in 1836 to Lime Street in the city centre from Edge Hill, billed as the longest surviving continuously operated station in the world. Lime Street was built with the first proper train shed constructed of iron and glass fronted by a magnificent screen in classical style, which made the perfect accompaniment to St George's Hall a few years later.

The year 1848, the Year of Revolution in Europe, witnessed great changes in the Liverpool railway scene too. The Lancashire and Yorkshire Railway (LYR) opened its line from Bury and Wigan, terminating at Exchange Station on Tithebarn Street. In the same year, the Liverpool, Crosby and Southport Railway was opened from Southport as far as Crosby to be extended two years later to join the LYR line. Work was also in progress on the East Lancashire Railway, opened the following year, which ran from Walton Junction on the LYR line to Preston. Also under construction and opened that same year were the Waterloo and Victoria tunnels connecting Edge Hill to Waterloo Dock. These were built by the London and North Western Railway (LNWR), which had been formed from an amalgamation of the Liverpool and Manchester Railway and other companies. It is a measure of the confidence in investment in the region at the time that all these schemes progressed in spite of the collapse of the Railway Mania in the mid-1840s.

During the next fifty years, there was enormous expansion in the provision for freight traffic to and from the docks. The LNWR and the LYR vied with each other constructing branches from their main lines to no less than five goods stations for the north docks, one of them involving the construction of the LNWR inner ring line from Edge Hill to Bootle. The Cheshire Lines Committee (CLC), a consortium of companies including the Midland Railway, built Brunswick goods depot in the south in conjunction with its line from Manchester through to Central Station, which was opened in 1874. It then ambitiously constructed an outer ring line running through West Derby to Aintree with a branch to Huskisson Goods Station. This line facilitated the Midland Railway's invasion of LNWR and LYR territory with Sandon and Langton goods branches in the north. Later, the CLC line was extended to Southport in unsuccessful competition with the more direct LYR line through Crosby.

In addition to these goods depots, from 1873 the LNWR built a vast freight complex at Edge Hill with a gridiron marshalling yard that attracted attention from all over the world. The LYR also constructed a huge yard at Aintree. All along the docks, the Mersey Docks and Harbour Board had developed their own intricate system of freight lines and with it grew the need of a line to convey the dockers along the length of the docks. This had to be above ground to avoid conflict with the dock railway network and so the Overhead Railway was born. Constructed along the line of the docks in 1893, it was the world's first electrified overhead railway with the first automatic signalling and electric signal lights. When it was extended both ends between 1894 and 1905 to encourage tourist and through traffic, Seaforth Sands Station boasted of the second escalator in the country. Meanwhile in 1886, the Mersey Railway had opened up a new direction of communication by burrowing under the river to Birkenhead and the Wirral, the world's first deep-level underground line, the first under a tidal river and the first railway in Britain to be converted from steam to electricity (in 1903). The Liverpool to Southport route followed soon after to be the first main line in the country to be electrified.

In 1956, the Overhead Railway closed when the decking was found to be corroded by the sulphurous fumes from the dock engines underneath. The decline of the traditional docks led to the closure of all the dock lines, except for one along the 'Bootle' branch to the Royal Seaforth Container Dock. The Beeching cuts closed the ring routes, but the Liverpool to Southport line survived a threat of closure. The present Merseyrail underground network was formed in 1977 by an ingenious loop extension of the Wirral line in conjunction with a north–south link involving closure of Exchange and Central (upper level) stations. Over the last few years, the network has consistently had one of the best records for punctuality in the country and forms a fitting conclusion to a journey through time on Liverpool's Railways that starts with the momentous Rainhill trials.

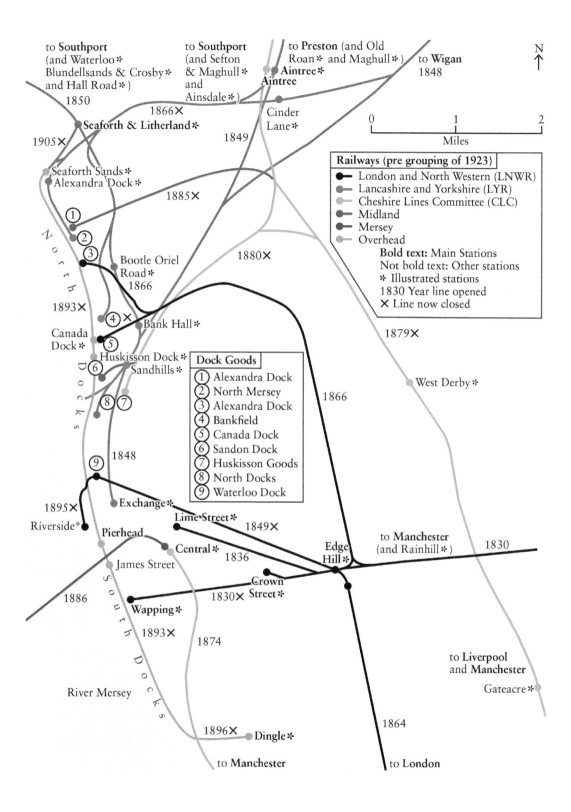

to **Southport**
(and Waterloo ✷
Blundellsands & Crosby ✷
and Hall Road ✷)
1850

to **Southport**
(and Sefton
& Maghull ✷
and
Ainsdale ✷)

to **Preston** (and Old
Roan ✷ and Maghull ✷)

to **Wigan**
1848

N
↑

Aintree ✷
Aintree

Cinder
Lane ✷

1866✗

Seaforth & Litherland ✷

1849

0 1 2

Miles

1905✗

Seaforth Sands ✷
Alexandra Dock ✷

1885✗

Railways (pre grouping of 1923)	
●—	London and North Western (LNWR)
●—	Lancashire and Yorkshire (LYR)
●—	Cheshire Lines Committee (CLC)
●—	Midland
●—	Mersey
●—	Overhead

Bold text: Main Stations
Not bold text: Other stations
✷ Illustrated stations
1830 Year line opened
✗ Line now closed

①

②
③

Bootle Oriel
Road ✷
1866

1880✗

1893✗

Canada
Dock ✷

④ ✗
⑤

Bank Hall ✷

Huskisson Dock ✷
⑥ Sandhills ✷

⑧ ⑦

Dock Goods	
①	Alexandra Dock
②	North Mersey
③	Alexandra Dock
④	Bankfield
⑤	Canada Dock
⑥	Sandon Dock
⑦	Huskisson Goods
⑧	North Docks
⑨	Waterloo Dock

1866

1879✗

West Derby ✷

⑨

1848

1895✗

Exchange ✷

Riverside ✷

Pierhead

Lime Street ✷

1849✗

Edge
Hill ✷

to **Manchester**
(and Rainhill ✷)

1830

Central ✷

1836

James Street

1886

Wapping ✷

1893✗

1874

Crown
1830✗ Street ✷

River Mersey

to **Liverpool**
and **Manchester**

Gateacre ✷

1896✗ Dingle ✷

1864

to **Manchester**

to **London**

North Docks

South Docks

5

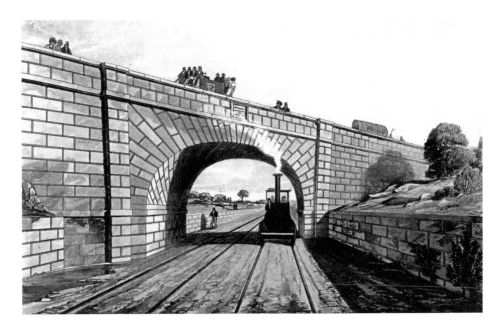

Rainhill Bridge

The Liverpool and Manchester Railway, opened in 1830, was the first 'inter-city' line in the world, carrying both passenger and freight traffic and hauled by steam. The preceding year had witnessed a key event in the industrial revolution where trials were held in nearby Rainhill to consider the feasibility of steam power. The skew arch bridge, built to carry the old turnpike road, was illustrated in a contemporary series of prints by T. T. Bury. It still proudly displays the names of the chairman of the line and its better known engineer. Just fitted with supports for overhead wires for the electrification of the line, the bridge straddles a 100-mph Newcastle to Liverpool Desiro Express as it thunders underneath.

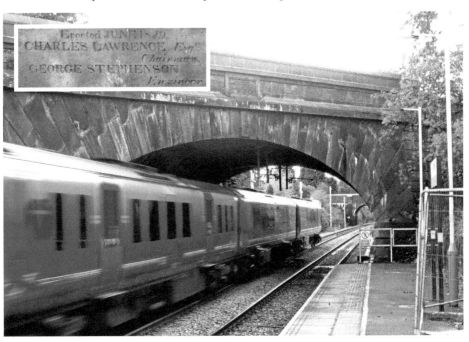

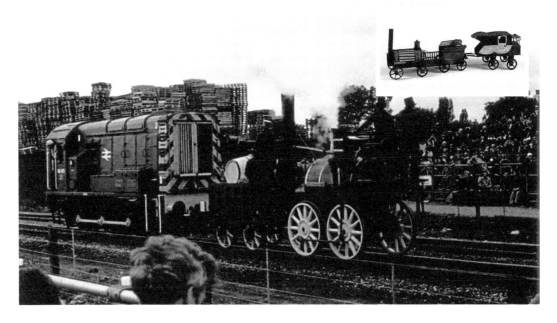

Rainhill Trials

The competition at Rainhill was won by George Stephenson's *Rocket*. It has been the prototype of standard steam locomotive design ever since. The great German polymath Goethe (died 1832) kept a model of the *Rocket* on his desk. To celebrate the 150th anniversary of the event, a cavalcade of steam locomotives was held at Rainhill. One of *Rocket*'s competitors failed again and had to be hauled by a modern diesel locomotive. Appropriately, 6201 *Princess Elizabeth* with a *Merseyside Express* name board hauled a sample of London Midland and Scottish Railway stock as she used to on her way from Liverpool and London.

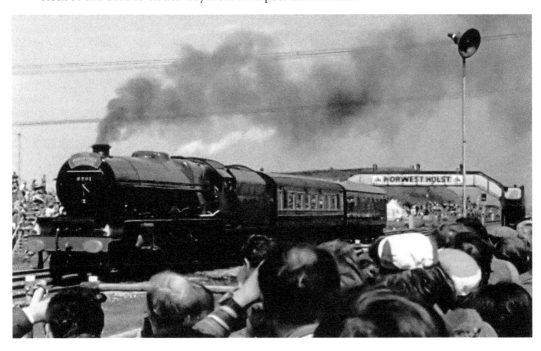

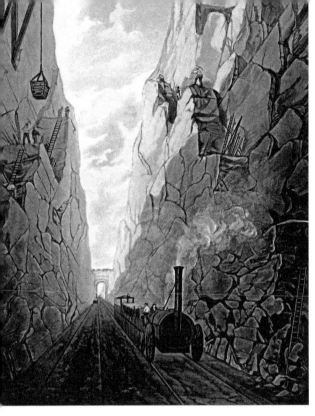

Olive Mount Cutting

To keep the gradient as level as possible and avoid traversing wealthy landowners' property, a vast cutting had to be excavated through Olive Mount, 4 miles from Liverpool. It ran for nearly 2 miles at its deepest over 100 feet; nearly half a million tons of spoil, much of it solid rock, had to be removed. The hazards before the advent of health and safety guidelines are graphically illustrated in a contemporary print. The recent electrification and re-laying of track make a striking contrast. Other major engineering works included, besides the Liverpool tunnels, the Sankey Viaduct (nine arches at 50 feet high) and the 5-mile crossing over Chat Moss. All have stood the test of time.

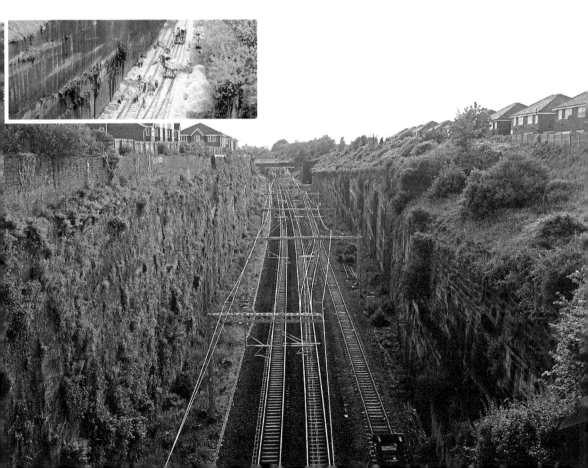

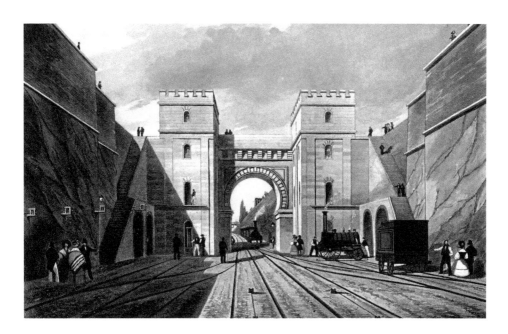

The Moorish Arch

The celebrated Liverpool architect John Foster Junior designed a Moorish Arch to act as a gateway to the Liverpool end of the line at Edge Hill. Foster specialised in classical architecture but chose an exotic design to give a sense of mystery and awe, hinting at the railway's potential to link up with the wider world of the East. The arch housed the stationary steam engines that provided the power to haul the trains up by rope (seen in the foreground) on the steep gradient from the docks. Another rope is guided through and stays on the left-hand side wall, maybe for signalling. The arch was demolished in 1860, a victim of the railway's success, as a wider line was needed to give additional access to Crown Street Goods Station, destruction comparable to the dismemberment of Euston's Doric Arch a century later. However, excavations in the 1970s revealed that the arch had been knocked down into its own cellar, so, theoretically, it should be possible to resurrect it.

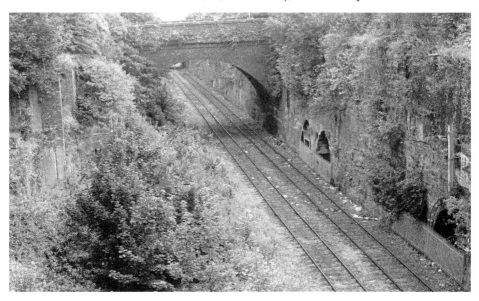

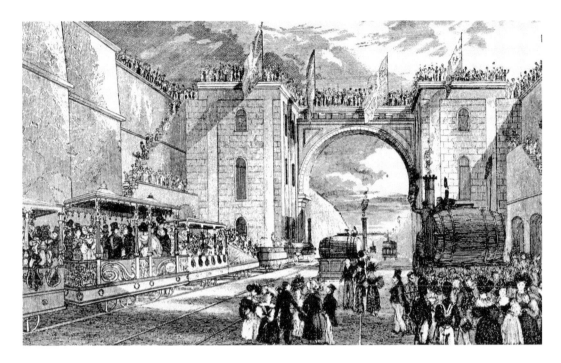

The Steam Era

The opening of the Liverpool and Manchester Railway – the first 'inter-city' service – was a national event. The Duke of Wellington, Prime Minister, is shown in his special coach to the left of the picture but scarcely two hours later celebrations would be marred by a dreadful accident. Liverpool witnessed both the beginning of the steam era with the revolutionary *Rocket* and its end when the last passenger train run by British Railways left Lime Street Station on 11 August 1968, returning via Carlisle and Manchester. The 'Fifteen Guinea Special' (£250 now) is seen starting from Lime Street Station.

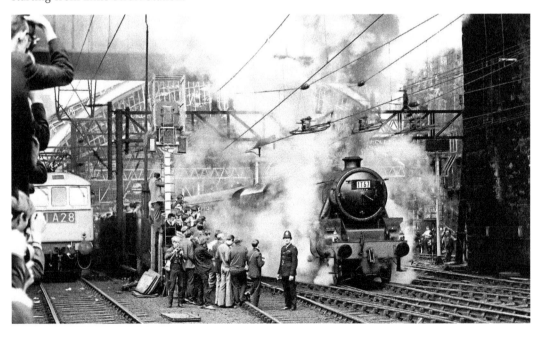

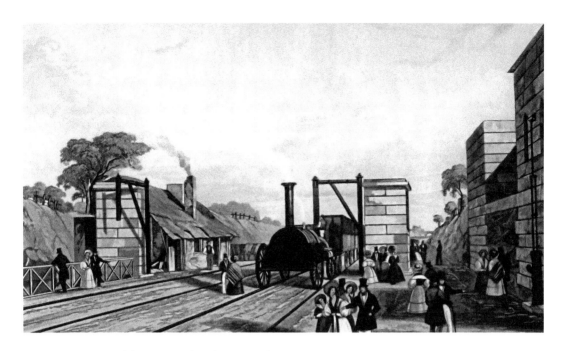

The First Widely Reported Railway Accident

At Parkside Station, halfway to Manchester, the inaugural trains stopped to take on water. The water cranes can be seen along with the caged wagons of the Second-Class passengers. Here, William Huskisson, one of the two Liverpool MPs, who had got out of his carriage onto the line to pick a quarrel with the Duke, was mown down by the *Rocket*. John Foster was again commissioned, this time to design an appropriate mausoleum for Huskisson, which stands today in the centre of the cemetery by the Anglican cathedral. A monument by the side of the line where he was struck down extols his virtues, ending with 'in the midst of life we are in death'.

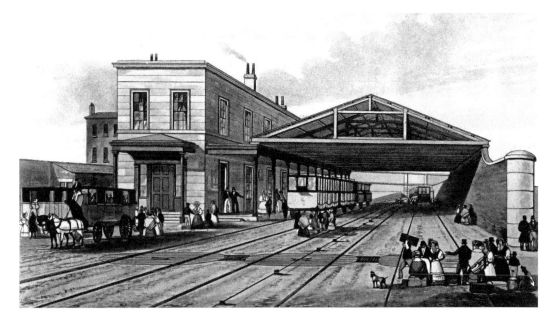

Crown Street Station

A busy, lively scene of arriving and departing passengers is enacted with more dogs than children accompanying the adults. First-Class carriages stand in the train shed, but the lack of platforms must have caused passengers difficulties, particularly for the ladies. They would then board road carriages bound for town. The classical architecture of the handsome doorway and columns supporting the canopy is well depicted together with the mechanisms for moving railway carriages from one track to another and for hauling trains through the tunnel, which could cause a hazard. Now only the ventilation tower for the Wapping Branch is left to remind us of the historic site with one of its fitments.

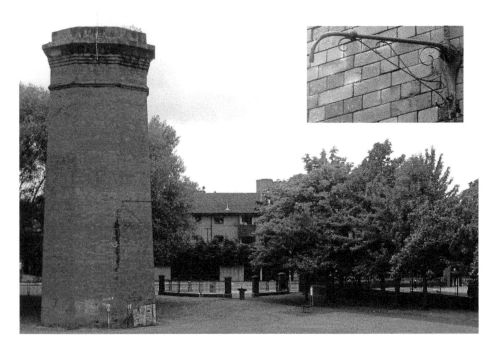

Crown Street Coal Yard

When the extension from Edge Hill to Lime Street was opened, there was no longer any need for the Crown Street passenger terminus. The railway premises were then converted entirely to coal distribution, which remained in operation until 1972 as shown (*Copy © Courtesy: liverpoolhistorypress.co.uk*). The approach to the yard was through a short tunnel starting just beyond the Moorish Arch. The photograph was taken after the original tunnels had been closed, while the later link was still in operation with (from right to left): the original 1829 tunnel to the Crown Street terminus; the tunnel to Wapping Goods; the new 1846 tunnel to Crown Street when it was converted to a coal yard (*inset*: before closure with the curious dead end).

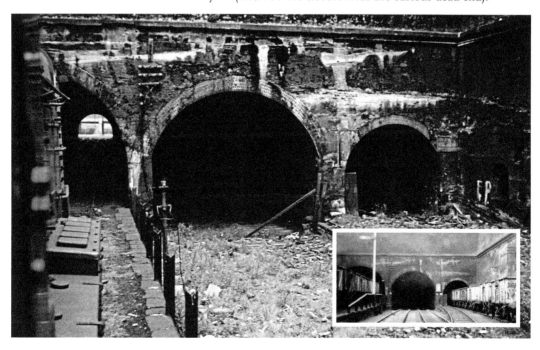

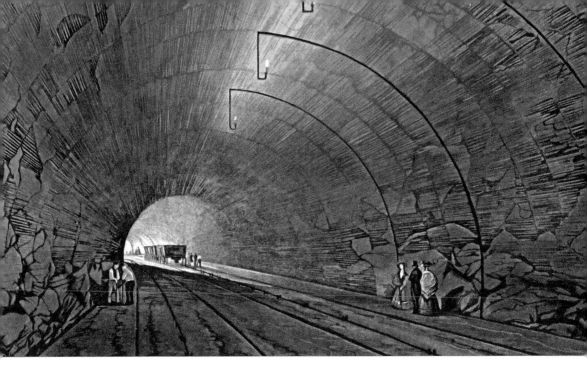

Wapping Tunnel

Freight was more important than passengers for the railways of Liverpool from the start until containerisation in the 1970s. Originally, a tunnel ran down from Edge Hill to a freight depot at Wapping with wagons going down by gravity and hauled up by rope. It was lit by gas jets thirty yards apart. The power was provided by steam engines at the Moorish Arch. Most of the tunnel remains more or less intact and could be utilised for tourist purposes or a traffic link.

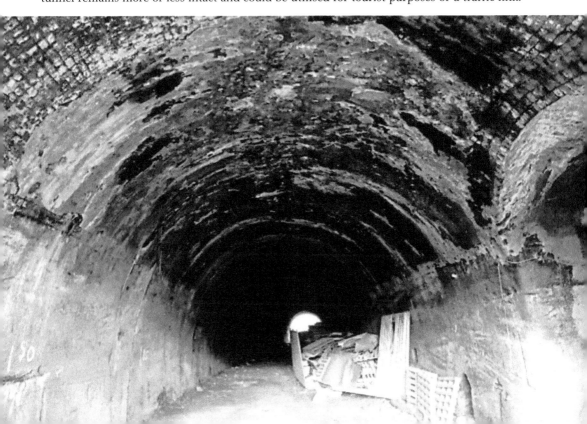

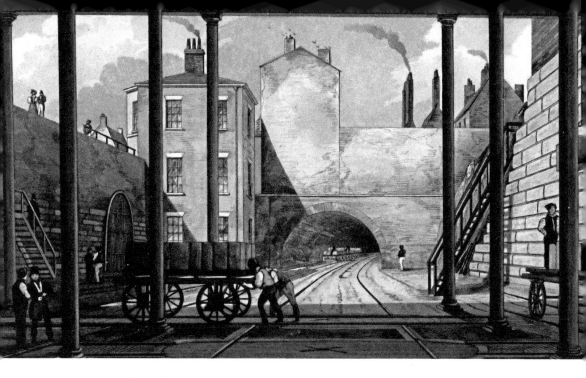

Wapping Goods Station

At the end of the Wapping Tunnel, the railway fanned out into four tracks. Turntables, only vaguely understood and delineated by the artist, moved trucks from one track to the other by means of rails turning on large moveable circles of wood. The goods were unloaded into warehouses above the tracks through hatchways aligned above as on the right of the print. Now, there is no discernible trace of this, the first waterfront goods depot in the world, but the mouth and first part of the tunnel are still intact and visible.

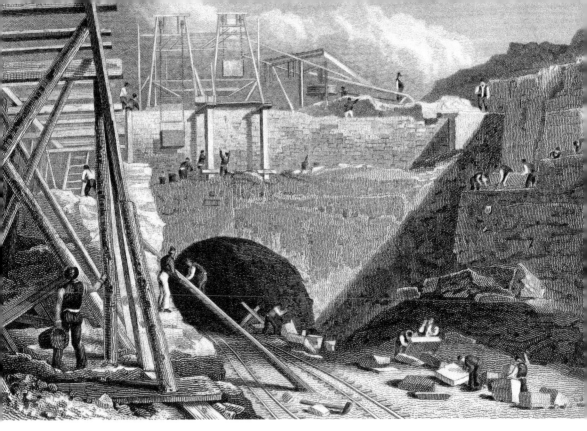

Edge Hill Tunnel

In 1836, the line was extended from Edge Hill through a tunnel to emerge at Lime Street. Here, it is being constructed involving many hazardous practices. Of special concern are the scaffolding, particularly supporting the machinery (*top right*), cranes without visible means of propulsion or direction, and the irregularity of the narrow-gauge contractor's line. Most of the tunnel has been opened up to form a formidable sheer-sided cutting through the sandstone with extra tunnels added, as shown (*inset*: commemorative plaque by the station's booking office).

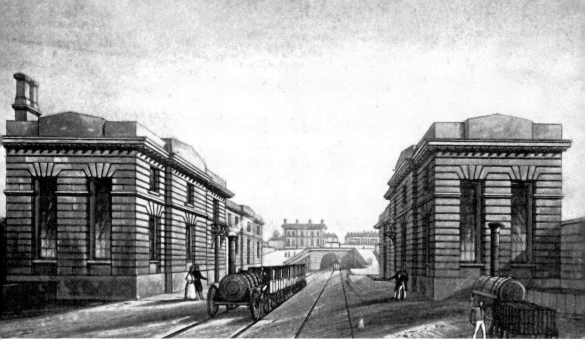

Edge Hill Station

When the line was extended to Lime Street, a station was constructed at Edge Hill in fine classical style. A train of diminutive First-Class carriages is being hauled by a locomotive without a tender running on the right-hand line, the wrong way as the lines were then! By 1976, the buildings were derelict, and British Rail prepared to demolish them. However, the North West Society for Industrial Archaeology and History proved that it could be the longest continuously operated station in the world. As a result, the Department of the Environment listed it as being of 'historical interest' and the buildings were returned to something like their original condition as photographed. The portal and ramps leading down to the station are recognisable today as a Pendolino emerges on the way to London.

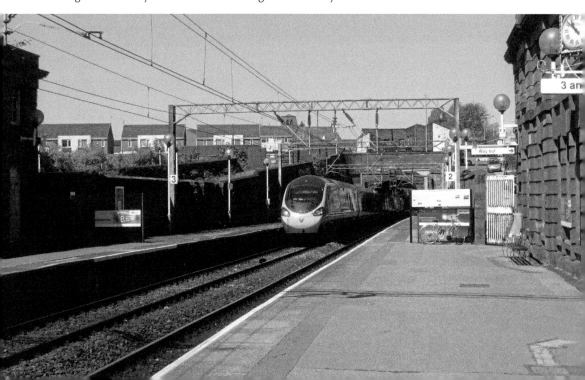

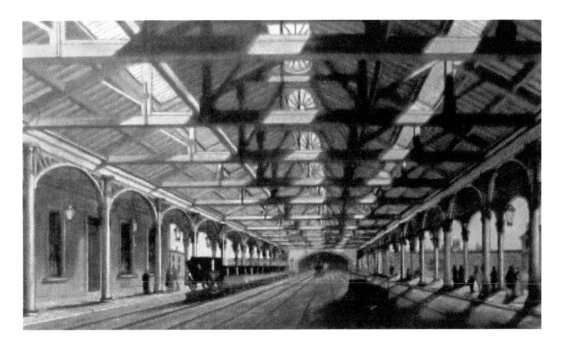

Lime Street Station Original

First Class passengers travelled in carriages modelled on horse-drawn coaches or even in their own coaches on transporters, as shown. The station, the first proper train shed to be constructed with iron and glass, was supported by columns decorated in classical style. In March 1835, John Foster Junior was again called on to prepare plans and drawings for a screen wall and other embellishments to be erected at the company's station in Lime Street. The Corporation thought it important enough to contribute £2,000 (£183,000 today). The stately and grandiose design was an early example of monumental commercialism with conspicuous ornamentation funded by the municipality. The view shows a typical street scene of the period leading to a station: from left to right: street vendors, stray dogs, country people and fashionable citizens with their luggage being carried for them and latecomers hastened on by a horse under pressure.

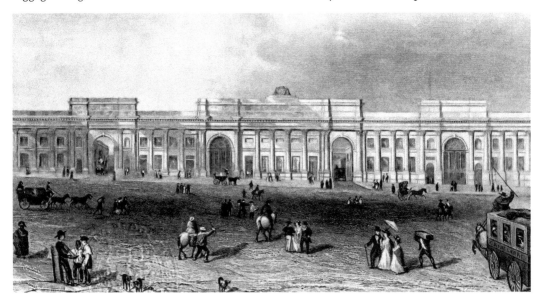

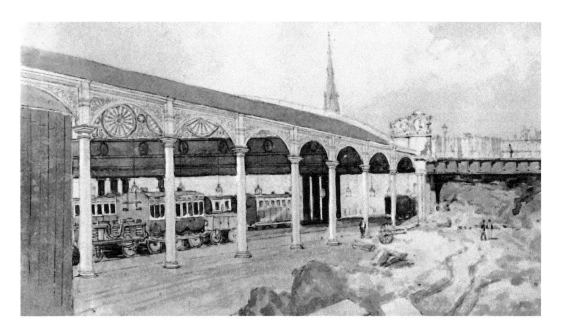

Lime Street Station Exterior

Work is in progress on a complete rebuilding of the 1866 station when the present station hotel was also constructed, now student accommodation. There is an interesting mix of six-wheel passenger coaches and wagons. A start has been made on demolishing the rear of the station with an ornate facade matching the front that incorporates a liver bird, and the lighting and beautiful decorative detail of the old station will soon disappear. Piles of earth are being shifted to widen the cutting and extend the tracks into the station. This threatens to undermine St Simon's, Gloucester Street, with its Gothic spire, which will be reconstructed further up the street, now entirely obliterated by the railway. *Below*, the new approach cleverly incorporates ramped access, to avoid the steps, and a disguised lift on the left at the top.

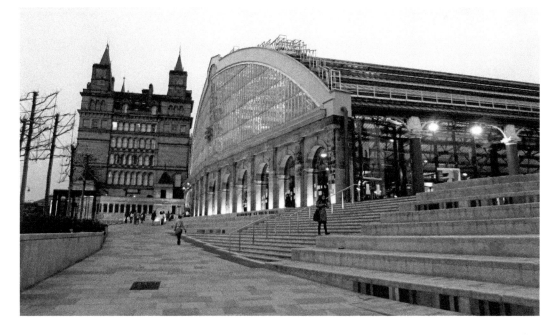

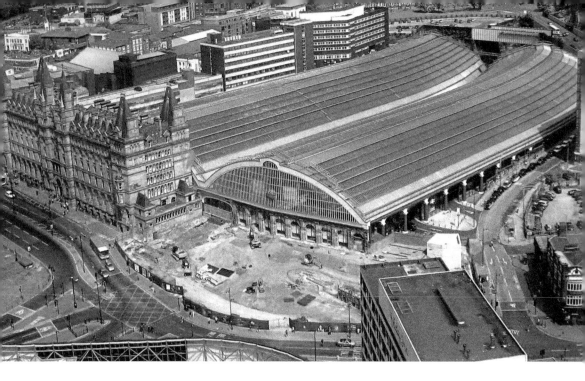

Lime Street Station Rebuilt

A recent view from above shows the beautiful curving sweep of the station and the hotel alongside, which unfortunately obscures half the frontage. The fine classical columns supporting the roof and picked out in red can be seen down the right-hand side. Work is in progress to demolish some shops that disfigured the front and to replace them with the new approach steps, but the effect as pictured inside was later spoilt by the carbuncle of Virgin's passenger centre.

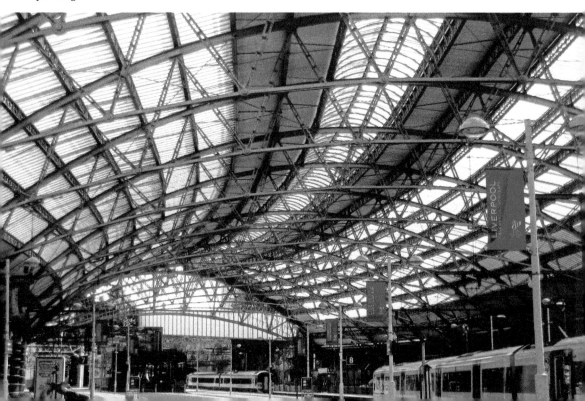

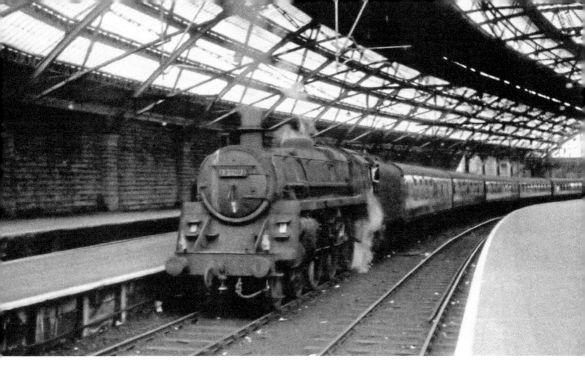

Liverpool to Llandudno
The 16.30 p.m. Liverpool to Llandudno train is preparing to leave platform 9 on 17 June 1965. Now, this journey would necessitate travelling via the Merseyrail network to Chester and changing there. The platforms to the left have now been converted into a rather cramped car park. The wide platform on the right, the departure point for the Virgin Pendolino services to London, is a relic of the old carriage way.

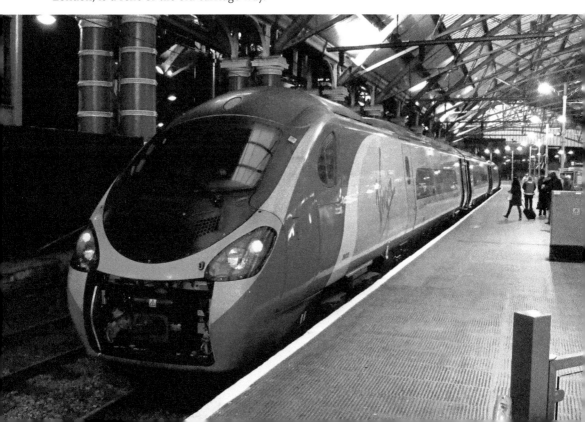

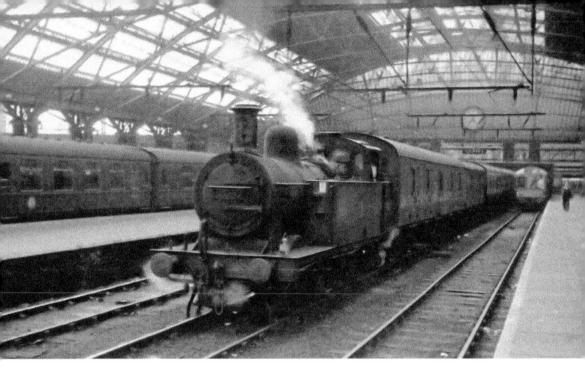

The Station Pilot

No. 47416 simmers in the spare carriage siding, useful in 1965 for empty stock, awaiting its next call. This class of tank engine, nicknamed 'Jinty', was ideal for shunting duties as 'station pilot'. On the right is one of the pioneer DMUs (diesel multiple units), while on the left, a maroon carriage displays the attractive original British Railways emblem on its side. Later, the siding was useful for storing electric and diesel locomotives (*inset*) but is now unused with the complete takeover by multiple units as pictured.

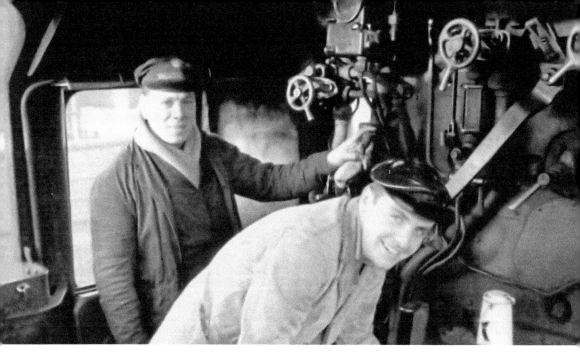

Engine Drivers and Firemen

Wally Reynolds and Georgie Newton, crew of 2-8-0 No. 48746, are extremely cheerful and in good shape as they prepare to work a pre-fab train (with prefabricated track) from Fazakerley to Blackburn. *Below*, is a view from the cab of a locomotive of the same class as it crosses Townsend Lane on the Bootle Branch. In fact, the work could be physically harsh, extremely dirty, unhealthy and dangerous, even fatal. A plaque (*inset*) on Platform 1 of Lime Street Station (transferred from Edge Hill shed, now demolished) records the deaths of the crew of a locomotive that suffered a collapsed smokebox deflector plate. The resulting blowback turned their footplate into a furnace but they stayed at their controls until they had brought the train safely to a stop. Both died later of their burns.

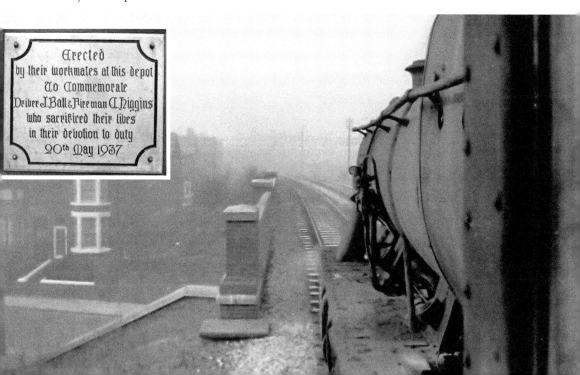

Erected
by their workmates at this depot
To Commemorate
Driver J. Ball & Fireman A. Higgins
who sacrificed their lives
in their devotion to duty
20th May 1937

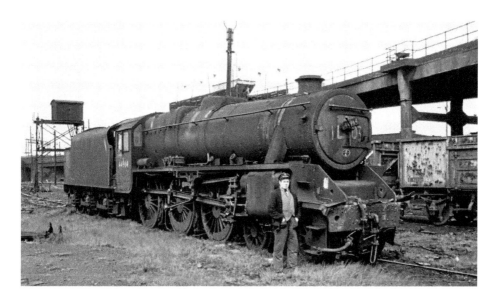

Edge Hill Shed

A 'Class 5' locomotive is looking battered and forlorn at Edge Hill shed (the locomotive depot for engines working out of Lime Street Station and Edge Hill sorting sidings): no wonder as it had just retired prematurely and suddenly ten hours beforehand after being the victim of a multiple shunt by a train running away down the gridiron (*see opposite*). Engines were graded 1–9 on a power basis, so a Class 5 was mid-range, but No. 44964 was credited with a speed of 88 mph on a passenger service. They performed well with freight too, and 842 of the class were built over a period of seventeen years, an average of one a week. The Class 5s were often referred to as Black Fives because of their livery: black, lined in red and yellow. *Above*, No. 44964 is a grimy grey in her last days of service, but *below*, preserved No. 45156 sparkling bright and named *Ayrshire Yeomanry* is hauling a special under the wires as it passes Edge Hill motive power depot in 1968. *Inset*: a Class 5 hard at work near Ormskirk in 1966.

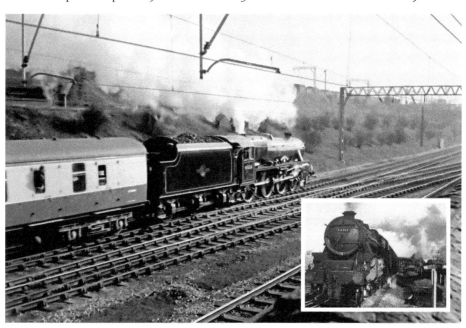

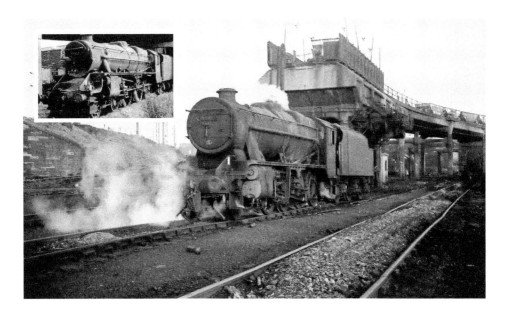

Edge Hill Gravity

Locomotives at Edge Hill shed (*above*) made ingenious use of gravity in coaling. Freight wagons in the adjacent marshalling yard were also propelled over a 'hump' and then, as they descended by gravity, sorted into different dispatch sidings according to their destination. Accidents could happen (*inset*). The revolutionary layout started in 1873 and was called a 'gridiron' because of the pattern of the tracks. It attracted attention from all over the world, and the complex incorporated flyovers and tunnels to separate the flow of traffic as seen below with the gridiron sidings to the right of the photograph. A variety of motive powers can be seen, from left to right: fireless, steam, electric and diesel. As with so many British inventions, there are no examples left in this country, but hundreds are still operating throughout the world.

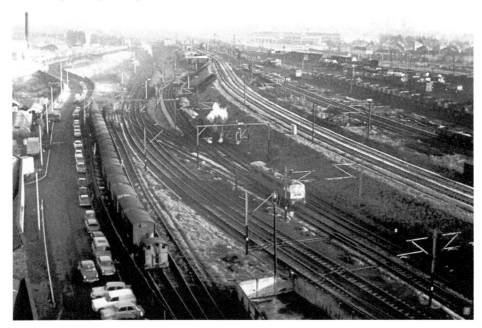

Great Howard Street

Next into Liverpool after the Liverpool and Manchester Railway, in 1848, came two lines from the north, later to amalgamate as the Lancashire and Yorkshire Railway (LYR). One of them from Wigan and Bury and another from Preston joined at Walton Junction and descended finally over a viaduct to a terminus at Great Howard Street. When Exchange Station was opened, the station at Great Howard Street was converted to goods and wagon lifts were constructed. Trucks were transferred from the sorting sidings into the warehouse by means of a turntable illustrated below and reminiscent of those used by the Liverpool and Manchester Railway. *Below*, is the other side of the goods station fronting onto Waterloo Road.

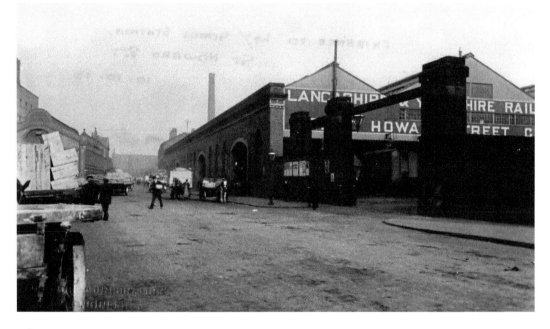

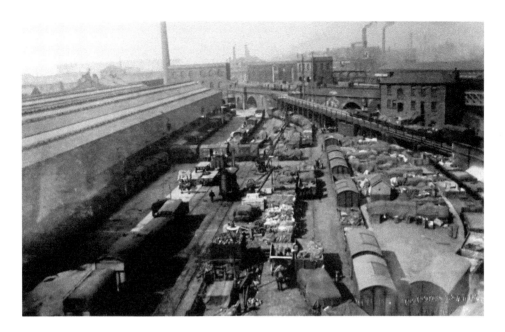

Great Howard Street Goods Station

The scene demonstrates a mix of man, horse and mechanical power. The viaduct leading down to the depot marks the descent now followed by Merseyrail's Northern Line to tunnel through to Central Station. The aerial view shows a train on this section of the line with a retail park to the left of it on the site of the Great Howard Street Goods Station. Top left, where the line to Sandhills curves to the right can be seen the start of the main viaduct to Exchange Station, now truncated and partially demolished (detail on page 30). The course of this ran through the car park to the right of the train. The portal of the Waterloo Tunnel can be seen halfway along the car park to the right with the line continuing through under a magnificent arch below the Great Howard Street viaduct behind the trees to the left of the car park.

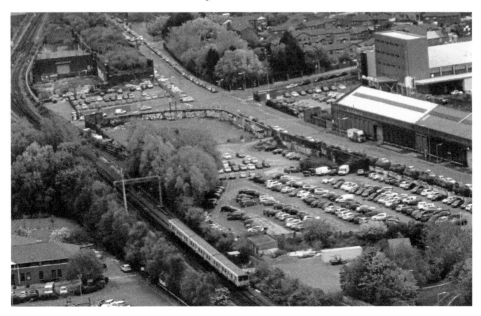

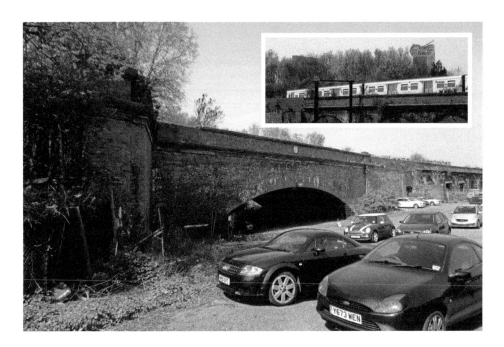

Arches

To carry its Great Howard Street extension over the London and North Western Railway (LNWR) line to Waterloo Goods Station, the LYR constructed a magnificent arch. Five and a half million bricks, it was said, were used, which now give shady shelter to a few cars. To the right of the bridge in the main photograph can be glimpsed the top of a train descending to the lower level line through the city centre (the inset shows a train there from a different angle). *Below*, is the arch's other side fronting on to Waterloo Road. The inset shows the plaque recording the names of the engineer and contractors: an indication of the importance placed on the achievement of its construction.

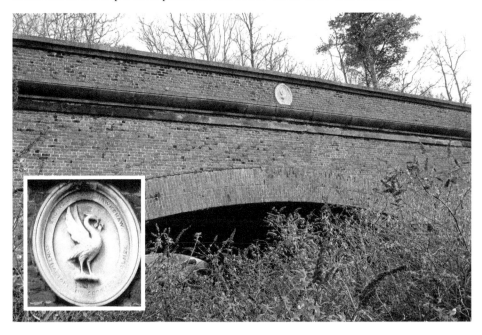

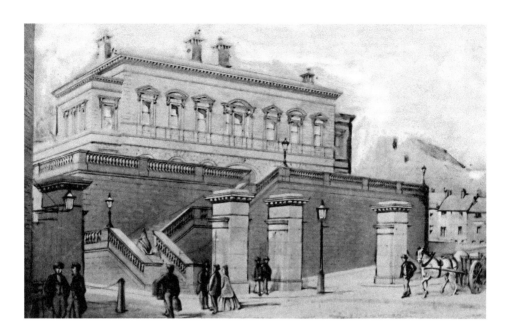

Exchange Station Exterior

The lines coming in to Great Howard Street Station were joined by the line from Crosby and Southport to form a new joint new terminus at Tithebarn Street (later, Exchange). Opened in 1850, the first Exchange Station was described as 'a magnificent structure built at enormous expense' and 'second in architectural effect to none in Liverpool'. Unfortunately, like so many other early Victorian station buildings, it succumbed to the need for expansion; and between 1884 and 1888, it was demolished and replaced by a much larger building of superb classical design. The pilasters of its fine façade are decorated in the approved ancient pattern with the Doric style on the bottom, Ionic above that and Corinthian on top.

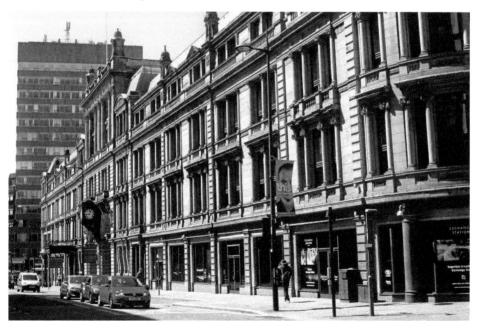

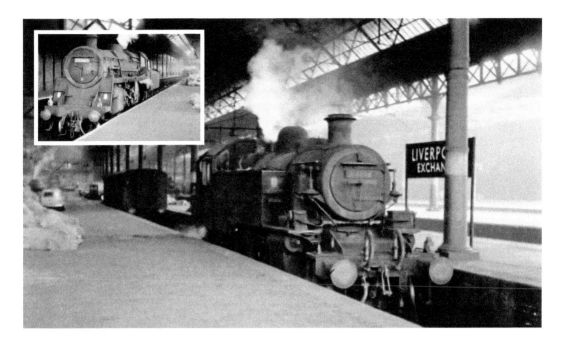

Exchange Station Interior

The station pilot Jinty 40211 is awaiting call to duty in Exchange Station in 1965, maybe in connection with the mail bags on the platform. On the other side of the platform (*inset*) is 75060 British Railways standard engine, a development of the Class 5s. Sporting express train head code (a lamp over each buffer), it may be about to depart for Blackpool or Glasgow. By then, the most frequent services ran to Southport, Ormskirk and Kirkby (the front of one of the electric trains with its indicator peeps out to the right of the station name board). Twelve years later, the station was closed and a car park created from the platform area and main approach viaduct. Below, can be seen the point at which the main viaduct into Exchange Station was cut off but nature has bounced back sprouting an overhead wild park waiting to be tamed and enjoyed.

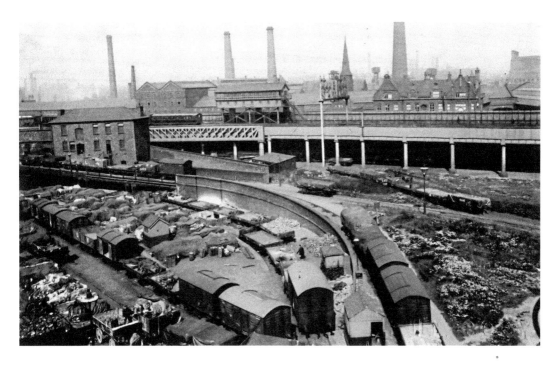

Exchange Viaduct

Another view from Great Howard Street Goods Station showing the approach viaduct to Exchange Station in the background with Exchange B signal box in view. *Below*, Class 5, No. 45412 awaits the green light to take an Everton Special away from Exchange Station on 23 April 1966 with signal box A still in situ. In the distance can be seen the tail end of a previous train. The numerous tracks leave the station on an enormous viaduct narrowing to four tracks to carry the line over the Leeds Liverpool canal (as shown in inset) to Sandhills.

Everton Victorious

An Everton Special in the capable hands of Class 5, No. 45412 picks up speed as it passes Sandhills Station in 1966 on its way to Bolton where Everton beat Manchester United 1-0 at Burnden Park in the semi-final of the FA cup. Thirty-five minutes later, it was followed by another special. Everton went on to win the cup at Wembley against Sheffield Wednesday 3-2 but failed to win what would have been a record of winning the cup without conceding a goal on the way. In 2015, a train approaches carrying Everton supporters to their home match against Manchester United at Goodison Park. The line has now been reduced to two through tracks to create space for improved accommodation at the station. *Inset*: jubilant fans boarding trains at Sandhills after their 3-0 victory.

Bank Hall

In this 1962 view, the pairs of lines from left to right are the slow electric lines, the fast electric lines and the freight lines. These have been pruned back until only the first pair is operating, as today's photograph shows. The steps down from the booking office to the second island platform can still be seen blocked off on the right. In the foreground is one of three sculptures created by Phil Bews, formed out of horse/cattle drinking troughs once situated on the Dock Road and possibly over 200 years old. They are decorated with metal casts: a hare/rabbit, face of the moon and 'Industry' (*inset*).

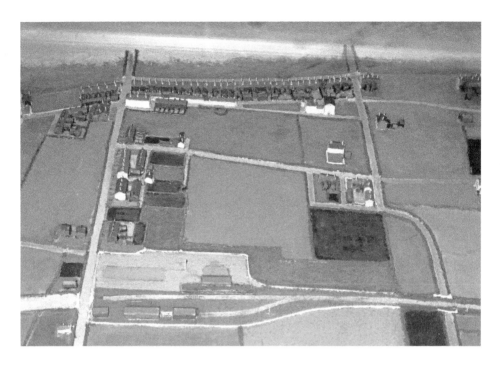

Liverpool, Crosby and Southport Railway

An 1848/9 aerial view of Waterloo Station in colour (taken from a model in the Local History Section of the Crosby Central Library). The single line from Southport (to the right) has just been opened as far as the original station on the Southport side of South Road. The line from there to Liverpool was opened in 1850 and subsequently doubled, with the station being relocated to its present position in 1881. St John's Road level crossing is to the right. In the modern aerial view taken from the opposite direction, the railway is barely discernible, enveloped by the housing development it has helped to create. It can be traced by the line of trees running centre left to right.

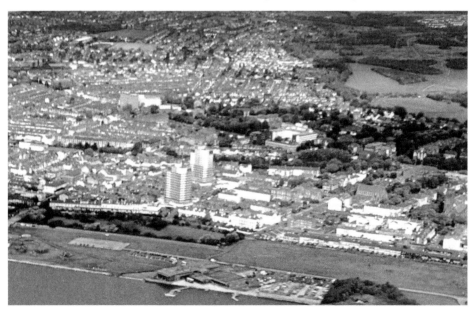

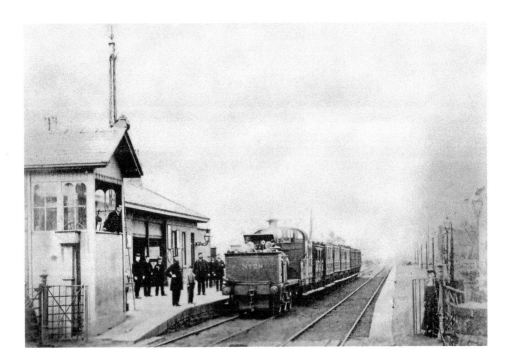

Crosby Station

An all-male cast (except for one of Dr May's daughters) faces the camera at Crosby Station, as it was first called, in the early 1880s. The signalman has turned the wheel to close the gates at the level crossing, but the signal is still in the on (stop) position. Photographed after Mersey Road Bridge was built and the station moved from there to Blundellsands Road, the engine has run around its train and is returning to Liverpool. Notice the 'bird cage' guards van and the motley collection of four-wheel carriages. Modern stock passes the old station building as it approaches the bridge.

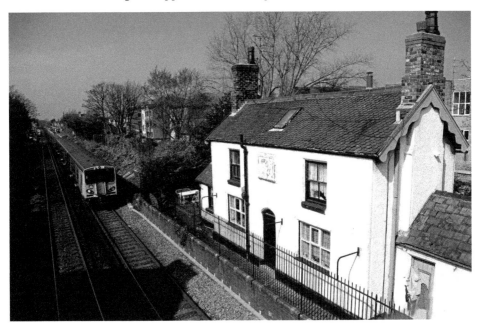

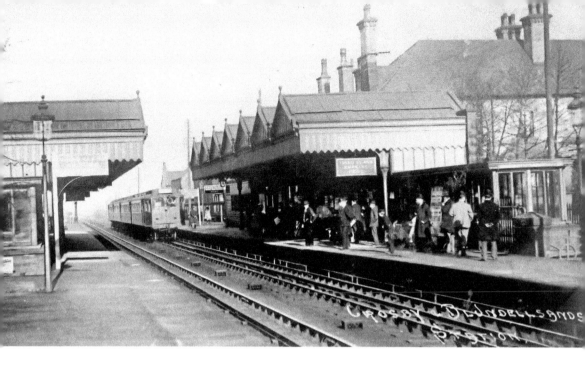

Blundellsands and Crosby Station

The attire of waiting passengers, gas lighting, magnificent canopies and two uniformed station staff waiting for the train comprise a typical Edwardian railway scene. Observe the notices directing passengers where to stand to board their appropriate carriage. Most are congregated by THIRD CLASS SMOKING HERE: none by first class ditto, only a few Third-Class smokers and the First-Class smokers if any are obscured by the train. It helped timekeeping, but smoking regulations have changed. Afternoon shoppers in different attire leave the train in the inset below. The canopies have been swept away, but some of the old buildings on the other side of the line remain. There are no station staff in sight.

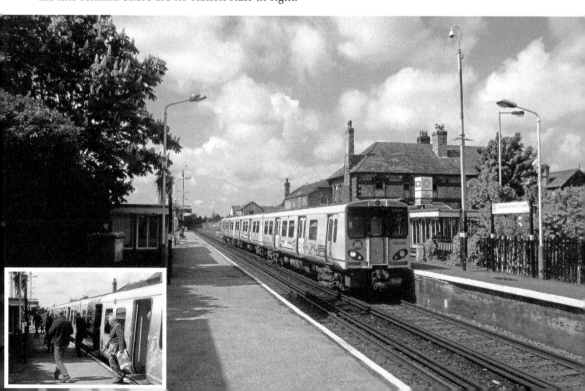

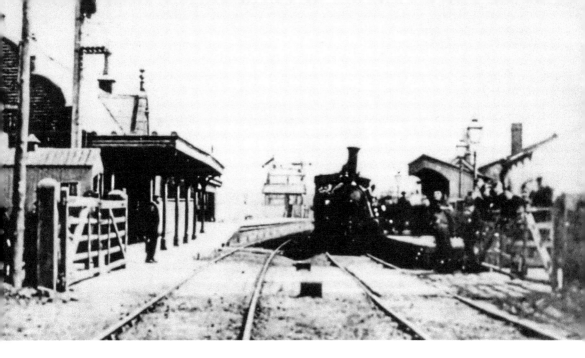

Seaforth and Litherland Station

It is 1876, and a Southport-bound train has stopped at Seaforth Station, as it was called then, which had been opened with the line in 1850. Ahead is a split signal indicating that a Liverpool-bound train is due to arrive but not diverted on to a spur on the right leading to the North Mersey branch line from Fazakerley, which ran to the docks. The railway originally ran on ground level at this point as far as a steep ascent to the canal crossing at Bootle, so the track was raised between 1885 and 1887 to eliminate this and the awkward level crossings, as here.

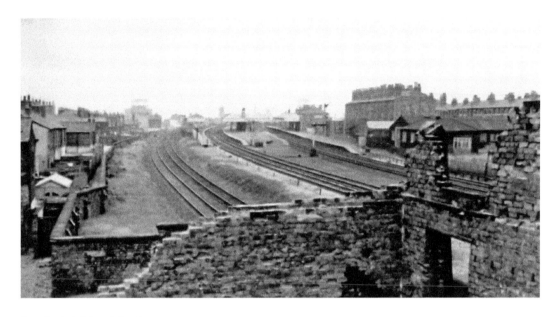

Bootle Oriel Road Station

Looking north from Millers Bridge, this view shows the complexity of railway lines before the Beeching cuts of the 1960s. On the left is a goods line from Bankfield Goods Depot that joins the Liverpool Southport line just beyond Oriel Road. The freight trains can then divert off the main line to Aintree marshalling yard at Marsh Lane junction further on. The duplicate (west) electric lines enabled express trains to overtake stopping trains at peak hours. In a tunnel running underneath Oriel Road Station is the branch line from Edge Hill to Alexandra Dock. Now only the right-hand (east) pair of lines is left. In the rebuilt station forecourt (*inset*), a giant steel sculpture, commissioned by Merseytravel and standing over eight metres tall, reflects and celebrates the history and growth of Bootle, its people and the wider Merseyside community.

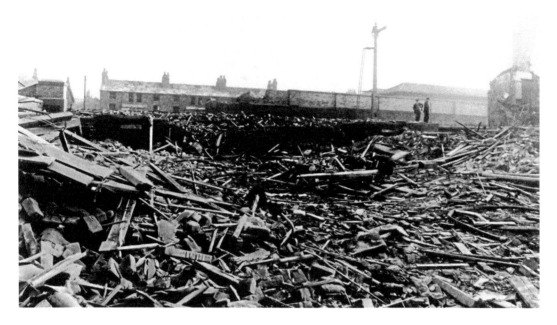

Blitz Damage

The immediate aftermath of a raid during the Blitz is vividly illustrated by a scene of terrace houses reduced to a pile of rubble. Only intense investigation established that this had been Berry Street on the west side of Oriel Road Station, identified by the wall along the opposite platform on the other side of the line behind the signal. In another view, some unscathed terrace houses are still standing with a steam-hauled freight passing along the line through Oriel Road Station onto the Seaforth Connecting Line to Fazakerley. Were the residents bothered by the pounding of the passing freight train or did they thrill to a sound now redolent of a bygone age?

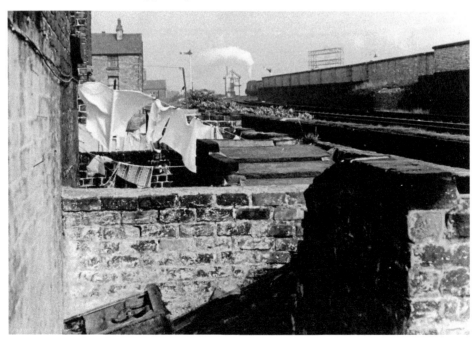

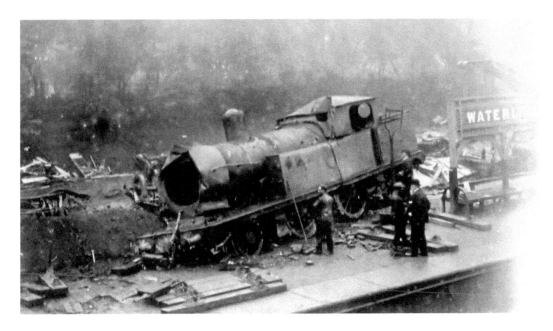

Waterloo Station Accident

Six people were killed in this accident on 15 July 1903. The steam-hauled express train travelling from Liverpool on the down grade through Five Lamps Bridge jumped the rails on the sharp curve approaching the station. Such was the force of the impact on a footbridge that the engine was slewed in the opposite direction. The arm of a breakdown crane removing the wreckage can be seen to the right. The engine, a 2-4-2 tank locomotive with large wheels, was ideal for working express and semi-fast trains but not for the acceleration required for an intensive local service. So the line was re-laid with a wider radius and electrification implemented the following year, illustrated in the 1985 view of a pre-privatisation train in British Rail livery accelerating away on the curve out of the station. Inset: the station's fine street-level canopy still survives.

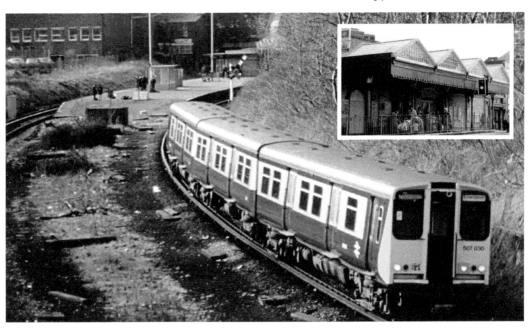

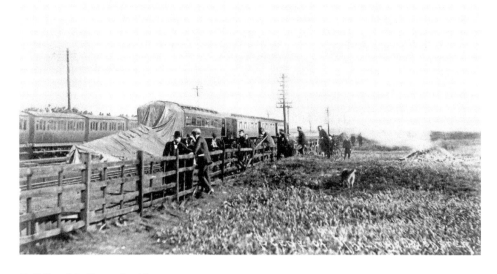

Hall Road Railway Accident

Only two years after the accident at Waterloo, and only three miles down the line, the worst railway crash in the Liverpool area occurred on 27 July 1905 at Hall Road Station when 20 people lost their lives. These were eventful years for the line, as in between it had become the first electrified main line railway in Britain. A local train from Liverpool terminated at the station and was shunted into a siding between the two running lines. Due to a signalman's error, the points had not been reset and a following express ploughed into it. The siding has since been lifted, but the space between the lines can still be seen in a view of track re-laying operations in 2001. Note the exhaust from the diesel locomotive needed when the electric current is cut off during work on the track. The inset shows a special in the 1960s at the same spot with signals that may have figured in the accident.

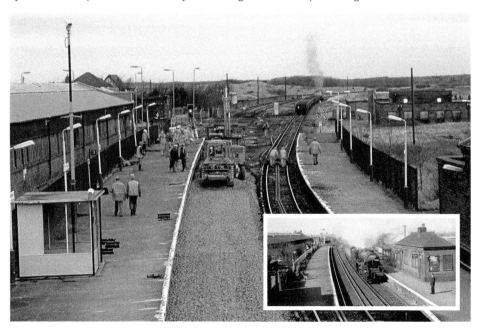

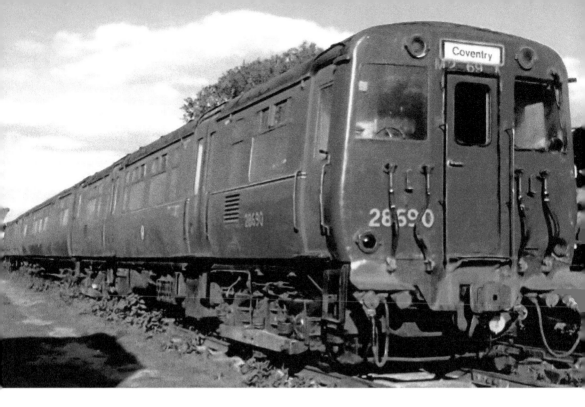

Livery: I

The two-tone brown of the early electrics was replaced by maroon when the LYR was merged into the London Midland and Scottish Railway in 1923. Pictured here is a preserved Wirral Line set at the Electric Railway Museum at Coventry. When nationalisation came in 1948, a livery of malachite green with straw-coloured lining was adopted. A set is pictured at Formby Station in 1968. Unlike many of the suburban stations on Merseyrail, the station has kept its buildings intact, maybe because they are on a bridge over the railway and a fine example too.

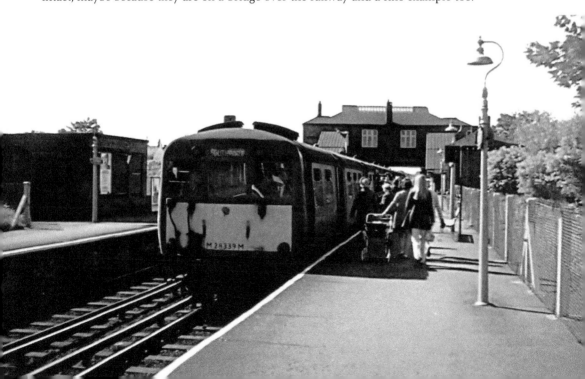

Livery: II

Under British Rail, the livery changed to all over blue and then blue and grey, as pictured at Hall Road with the maintenance depot in the background, now demolished and awaiting development. Privatisation introduced yellow and grey (*inset* of Merseyrail model in Rail House) and now the sets sport pure yellow with local attractions or blue advertising the Beatles. Pictured below is a set decorated likewise for the Liverpool Capital of Culture year of 2008.

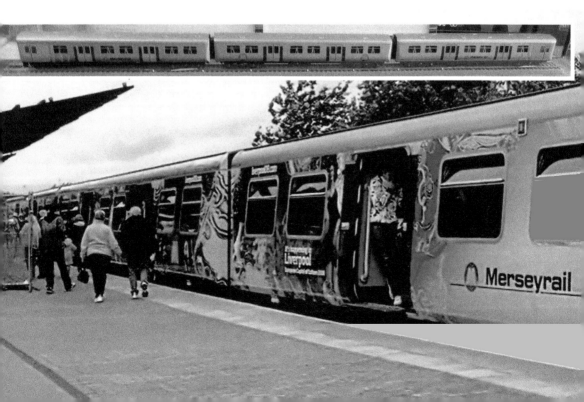

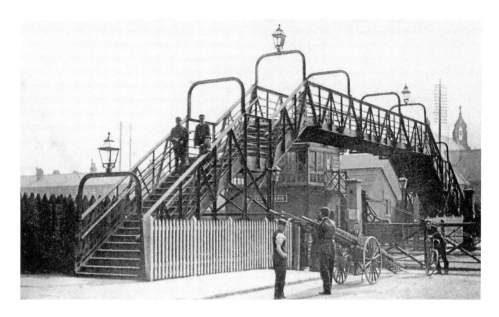

Level Crossings and Signals

A handcart and cyclist are held up at a level crossing (today, a string of cars). As the line from Liverpool to Southport descends to the level at Waterloo, this crossing is the first of many through to Southport where a road crosses the line on the level, except where an overbridge has been constructed. The scene is typical with the signalman in his box (here, 'cabin'), who has laboriously turned the wheel that opens and closes the gates. There is a well-lit footbridge to avoid waiting for the train to pass. Now the crossing is lit by a security light so that the barriers may be seen by a central control room (*inset below*) that oversees the whole system. This is at Sandhills (*centre below*) on the site of the Cheshire Lines Committee (CLC) Huskisson Goods Station, where a string of buses wait to transport football fans from the station to Everton's Goodison Park (or Liverpool's Anfield on alternate weekends).

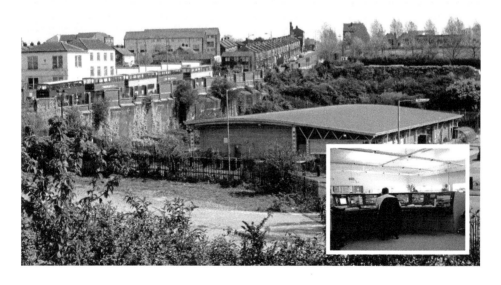

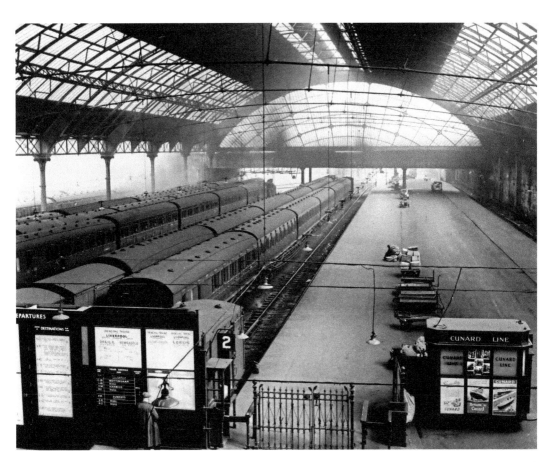

Central Station

Although last on the scene of the three Liverpool main line termini, Central Station, terminus of the CLC, was most conveniently situated for shopping. However, its catchment area for local passenger traffic was limited to the southern, albeit affluent, area of the city whilst its circuitous route was a disadvantage over longer distances. A 1953 view (*above*) shows it is well used. When the upper-level station was demolished, the line was electrified to Hunts Cross and its lower level became the hub of the Merseyrail network. The enquiry office on Bold Street and the left luggage office facing on to the pedestrianised Lyceum Place (*below*) are a reminder of the decoration in classical style that adorned the high-level station.

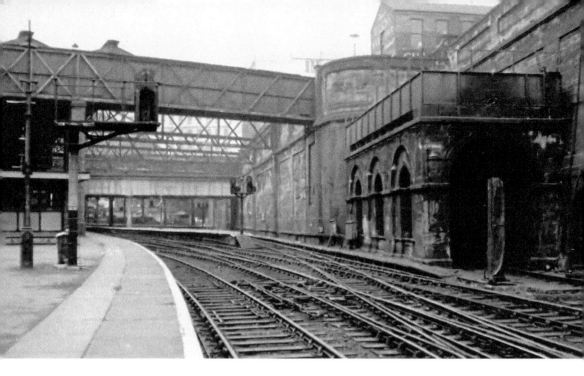

Central Station Approach

The extension from Brunswick Dock to Central Station was achieved at great cost: a total of 2,041 yards of tunnelling debouching onto an extremely restricted area. A photograph taken from the end of its main platform shows an engine refuge topped by a water tank. In the aerial view the bridges can be seen beyond the new Central Station next to the former Lewis's on the left. Plans were afoot before the recession to develop the area but have not yet been realised, and it remains in use as a car park.

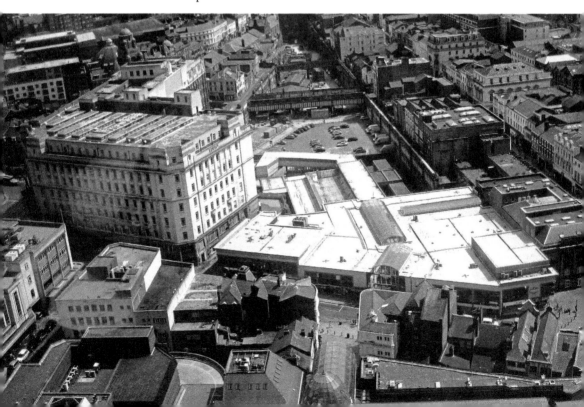

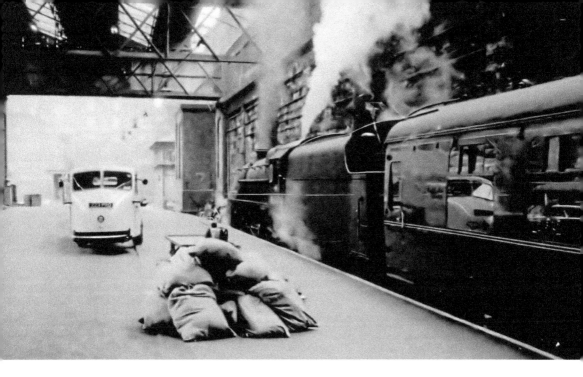

Central Station Exit

No. 45223 of the all-pervasive Class 5 has a full head of steam and is blowing off preparatory to departure in 1966 from Central Station to Central Station (Manchester). Bags (of mail?) lie on the platform beside a trolley and a three-wheel 'mechanical horse' is in attendance to handle the heavy stuff. The crew will have only a few yards of comparatively fresh air before the train plunges into Great George Street Tunnel, 1,320 yards long, now used by Merseyrail's Northern Line extension to Hunts Cross. A closer view of the signal box reveals disuse and decay. The semaphore signals have been replaced by colour lights, but the impressive array of signal rods emerging from under the box hint at a much busier past. The tower of the bombed-out St Luke's Church is just visible.

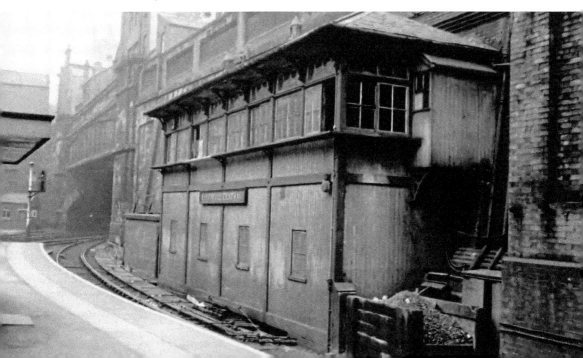

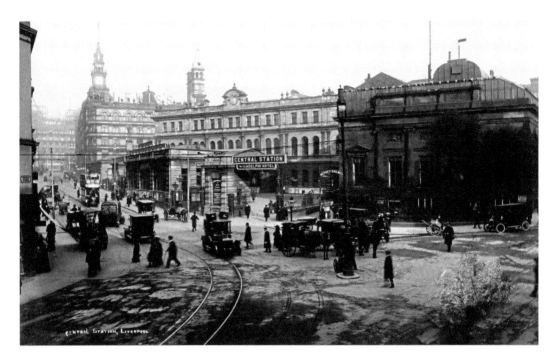

Mersey Railway Tunnel

The construction of the (third) Adelphi Hotel (*top, left*) has reached roof level, which dates the scene to about 1913. The entrance to the Mersey Railway can be seen to the right of the front of Central Station. The tunnel of the Mersey Railway was the first below a tidal estuary and the first deep-level line in an urban area. The pump house (*centre, below*) to keep the tunnel clear of water has survived through the Blitz and redevelopment. Observe the interesting reflections on the modern buildings. Together with a pumping station on the Birkenhead side, as much as 40,000 litres per minute could be extracted.

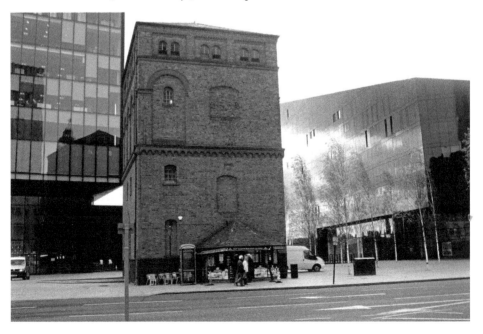

Mersey Railway Steam

Opened in 1886, the railway was at first operated by specially designed condensing locomotives like *Brunlees*. The crew, working in open cabs, must have been near-asphyxiated by smoke, and commuters suffered too with the result that they returned to travelling by ferry. This, combined with an expensive ventilation system, forced the railway into bankruptcy in 1888. In 1899, George Westinghouse arrived from the United States to pioneer electric traction, and the railway became the first in Britain to be converted from steam to electricity. It is now an integral part of the Merseyrail network. The pumping station on the Birkenhead side is next to Hamilton Square railway station, distinguishable in a photograph taken from the old Liverpool landing stage across the Mersey (the right-hand tower). *Inset*: the preserved 'Giant Grasshopper' pumping machine inside.

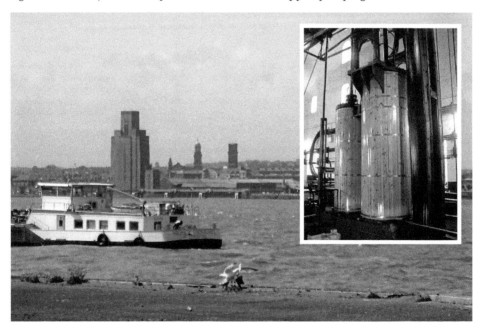

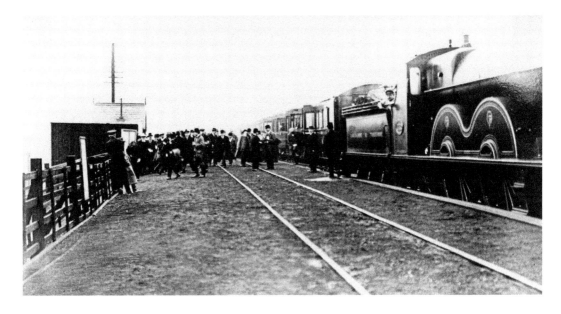

Aintree Cinder Lane Station

Racegoers, mostly bowler hatted, emerge from a train. The station is unique. As can be seen, the platform edge on the right is very low consisting of wooden baulks with cinder infill, and the track on the left has been raised to form a level surface by means of more cinder infill so the passengers can cross it without tripping to leave the 'station'. This ingenious arrangement was devised because the track was on an embankment with no room to build a platform alongside the tracks. On race days, the left-hand (eastbound) track was (understandably!) not used, and a one-way system operated on the other. A convoy of trains travelling west arrived between 11.00 a.m. and 2.00 p.m., as here, to return after stabling at Aintree shed, travelling east. The train is hauled by one of the LYR's express locomotives ('High Flyers') with high-pitched boiler and large driving wheels covered by beautiful wavy splashers. The track bed is now a cycleway.

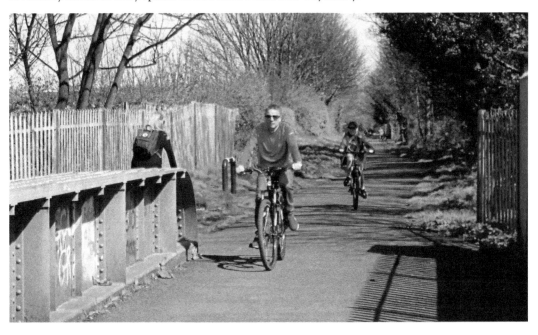

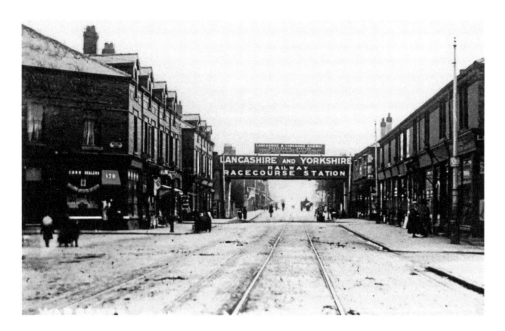

Aintree Racecourse Station

The LYR certainly advertises its Racecourse Station as the attractive 'Cinder Lane' was renamed in 1910. It seems overdone as it was only used once a year (admittedly in 1913 by thirty-four trains bringing in 10,000 passengers), and those who used it came from afar. The station was situated on the Fazakerley and North Mersey branch of the LYR built to carry goods between the north docks and the Fazakerley sorting sidings. It is now a cycle track shown in the photograph on the opposite page (taken on the bridge looking east towards the site of Cinder Lane/Racecourse Station on the left behind the cyclists). In the view above, the station was to the left (east side) of the bridge and racegoers would flood out down a sloping path to Warbreck Road. Local people would use the other Aintree stations such as the Sefton Arms (as the LYR station was sometimes known), bridge ticket office pictured below.

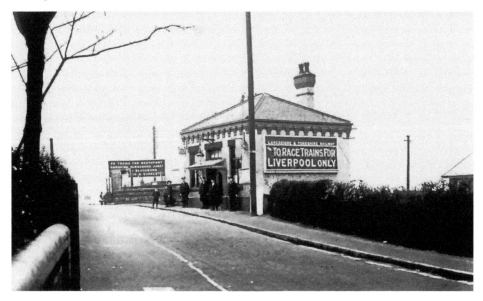

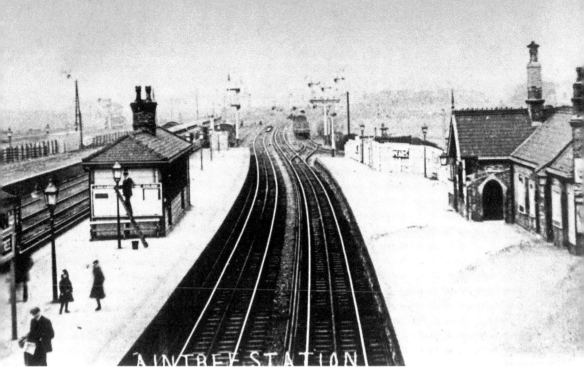

Aintree Station

In the early days, Aintree (on the LYR's main line from Liverpool to Preston) appears, and was, a quiet, country station only distinguished by extra platforms used on race days to the left. A view from the road bridge now with departing crowds in the 2015 Grand National shows a complete change: the old buildings and semaphore signals have been swept away and only remnants of the excursion platforms and track are visible. One of the new stands on the course itself can be seen top right.

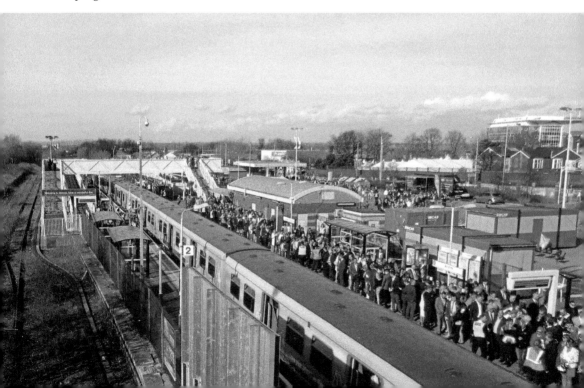

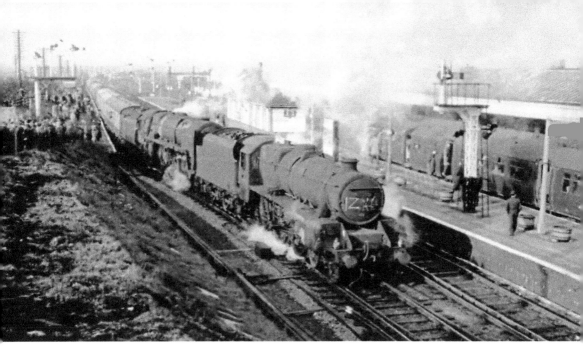

Tote Investors Special

Although this is the third of three trains departing at ten-minute intervals, the waiting crowd shows there is still more to carry them away from the Grand National. The 17.25 p.m. 'Tote Investors Special' of 1966 is drawn by No. 70031 *Byron* of the Britannia class piloted by No. 45330, one of the numerous Class 5s. *Byron* will be withdrawn the following year after only fifteen years' service. Chalked on the front of the smoke box, 'I' indicates that the train originated in the London area and 'Z' that it is a 'special' or 'extra'. An electric train heading the other way to Ormskirk with space to spare is filling up and an array of semaphore signals dictates the progress of the trains. Twenty years later, a preserved electric special in the British Rail maroon livery prepares to engorge the waiting Grand National crowds. Top left of the photograph, a set of Pullman coaches forms another special, now diesel-hauled.

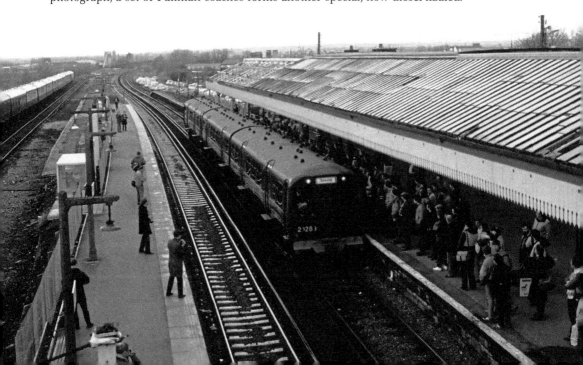

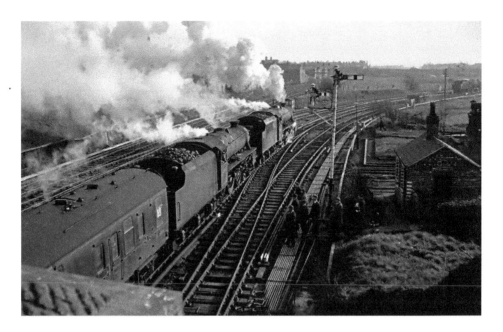

Aintree Grand National

With crisp smoke exhaust and full tenders of coal, the 17.15 p.m. Grand National special of 1966 is double headed by two Class 5s (pilot No. 45431 and train engine No. 45069) working in unison. Wisps of steam coming from the safety valves show the boiler pressure is high, so the fireman can afford to exchange greetings with bystanders on the point rods. The signals in the distance on the right are giving the train the all-clear, and by them, another engine is waiting by Aintree Shed to take on the next load. The line taken by the specials joined the Liverpool to Southport line at Marsh Lane Junction. Just before Bank Hall Station at Bootle Junction, they diverted through tunnels to reach the main Liverpool to Manchester line at Olive Mount Junction. *Below*, a 1986 special snakes through the Bootle Junction with a rake of Pullman carriages on its way from Aintree.

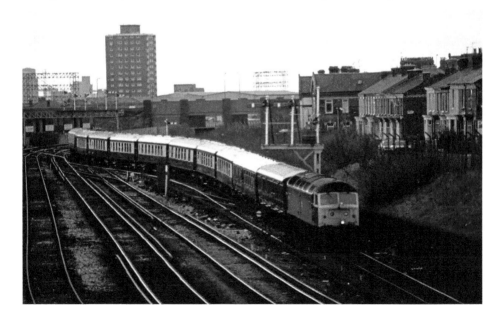

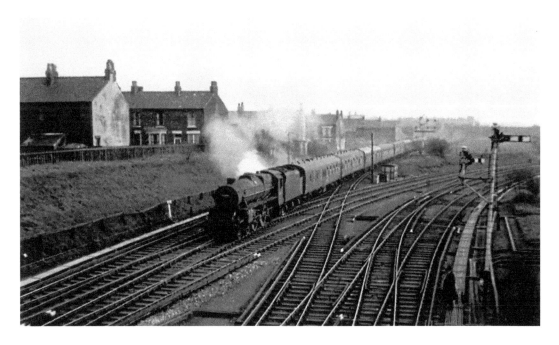

Aintree Connections

On a tight schedule in between specials and electric services, the 16.40 p.m. Exchange to Glasgow express speeds through Aintree behind Class 5, No. 45290 on Grand National day. Reaching this destination from Liverpool would now involve a change of train at Wigan or Preston. Between 1906 and 1951, electric services had also run from Exchange to Aintree over the line coming in from the right via Bootle and Ford, which the steam specials also used. In addition, through services ran from the Overhead Railway via this route until the end of the First World War and on race days thereafter. Traces of the conductor rails for electric trains can be seen, but the line was closed and 'mothballed' in 1994.

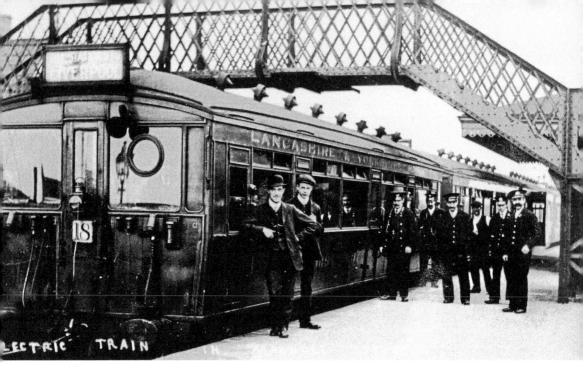

Maghull Station

The train crew and no less than six station staff pose by an LYR electric train at Maghull Station. Now one member of staff suffices. The solemnity of the occasion hints it may be in honour of the electrification of the line in 1909 with three trains an hour into Liverpool Exchange taking seventeen minutes or twenty-one minutes via Ford and Bootle. The population of Maghull at the time was little over 1,500. Since then, it has grown tenfold and more. Now the Merseyrail service to Moorfields (which replaces Exchange) running every quarter of an hour takes eighteen minutes (with an extra stop at Old Roan). The footbridge survives and also, unusually for Merseyrail Stations, the attractive buildings.

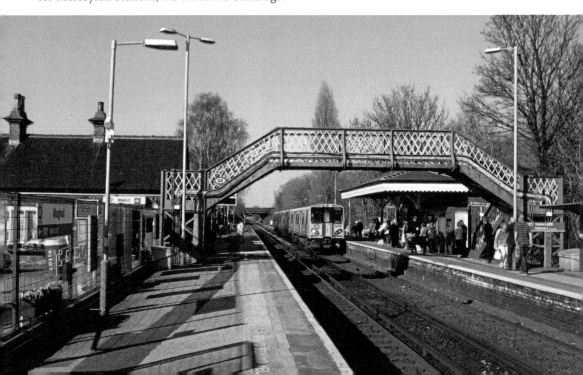

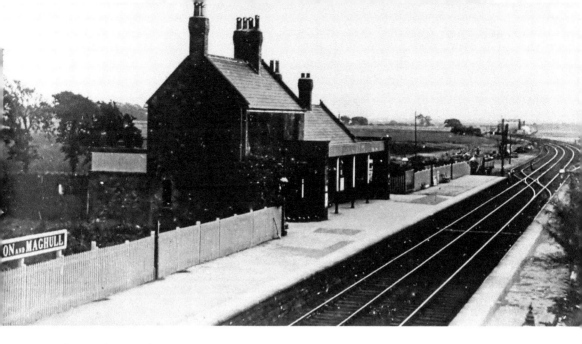

Sefton and Maghull

The view from Sefton Lane looking towards Liverpool is typical of the sleepy village stations on the Southport and Cheshire Lines Railway extension from Aintree to Southport. Once a year, Sefton and Maghull Station used to come to life when Sefton meadows were flooded and excursion trains brought skaters to the scene. The land on the left of the line in Maghull is now built up with an industrial estate and housing for commuters, but the view towards Sefton village is still as countrified as ever. The abutment of a bridge by Old Roan Station further on shows how it ran alongside the Lancashire and Yorkshire line as far as this point before veering away towards Southport. Two trains have stopped at the former LYR station, but there was no station on the CLC.

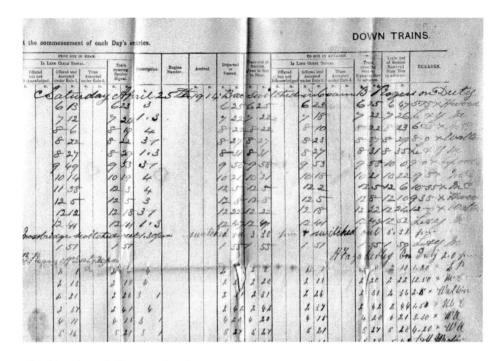

Cheshire Lines Railway to Southport

Signalmen B. Rogers and H. Fazakerley were on duty for eight hours at Woodvale signal box on 25 April 1914. Part of their meticulous record of train movements has survived and shows that the steam-hauled trains from Liverpool were interspersed with motor car services run by the LYR (right-hand column 'MC'; X means 'ex', i.e. 'coming from'). The roundabout route of the CLC from Liverpool Central via West Derby to Southport Lord Street was 31.5 miles long, compared with the more direct 18.5-mile LYR journey from Exchange Station to Southport Chapel Street, much of it through sparsely populated country. Not surprisingly, services ended in 1952 before Beeching's cuts. The crossing keeper's house at the next station along the line – Ainsdale, to the right of the photograph below – still marks the site of the line, which has been converted into a road. The aeroplane commemorates a transatlantic flight from Ainsdale beach to New York.

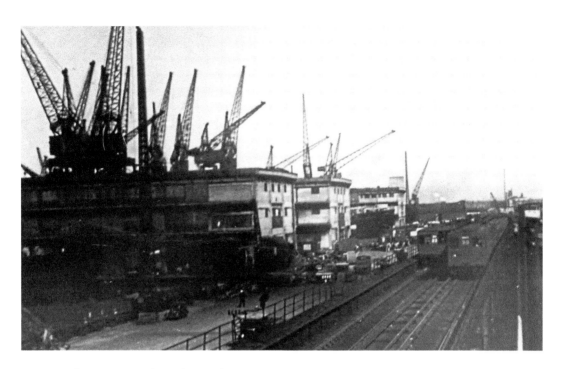

North Mersey to Alexandra Dock

The view of Gladstone Dock with the Overhead Railway in the foreground illustrates the prize that competing railway companies hoped to win: the lucrative dock trade. On a display in the Museum of Liverpool, the Gladstone Dock is top right. The Overhead Railway with three stations runs in brown from left to right between the docks and the warehouses. From left to right, the other most important stations are Alexandra Dock [Passenger] Station (LNWR); Alexandra Dock Goods Station (also LNWR, wrongly labelled LYR for Lancashire and Yorkshire Railway); North Mersey and Alexandra Docks Goods Station (LYR) and Alexandra and Langton Docks Goods Station (Midland Railway, one of the Cheshire Lines Committee companies): all within the space of a half mile.

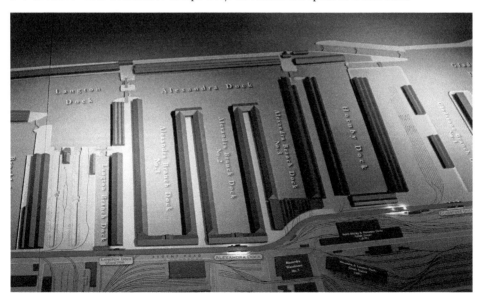

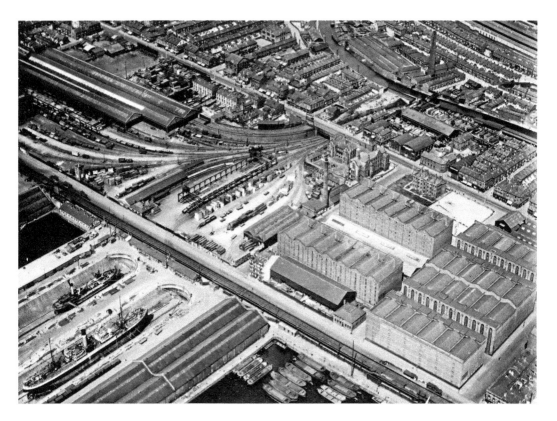

Alexandra Dock Rail Link

The LNWR opened their Bootle Branch from Edge Hill to the Alexandra Dock in 1866. *Above*, the sheds of the LNWR are conspicuous top left, with in the centre the connection to their main sorting sidings at Edge Hill burrowing underneath the canal, which can be seen as an arc top right of the photo. By 1998, the whole complex had been demolished except for one line that is being fenced off to form what remains now as the only rail link with the Royal Seaforth Container Port.

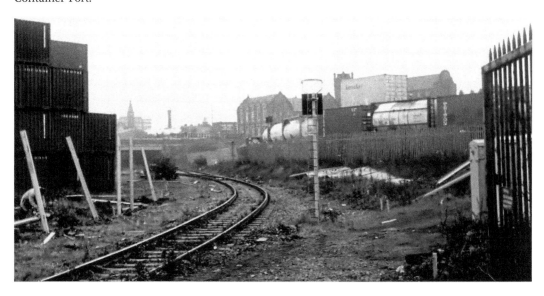

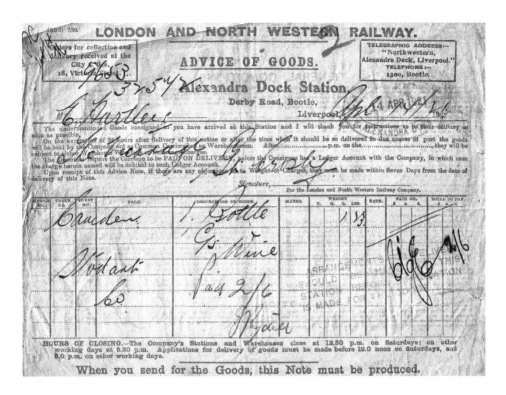

Alexandra Dock Stations

An advice note dated 14 April 1921 shows the changed nature of delivery of goods. One bottle of wine was to be collected from Alexandra Dock Station or delivered, with payment on the spot. The London and North Western's Station was the first of four with the same name: its own passenger station, the Overhead Railway and another goods station run by its rival the Midland Railway. Now all are gone. In the 1934 aerial photograph, the LNWR shed is prominent in the middle distance with two out of the three grain elevators of the dock itself top right.

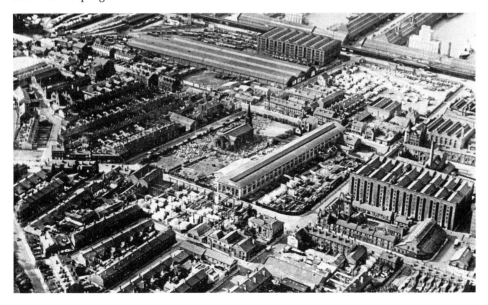

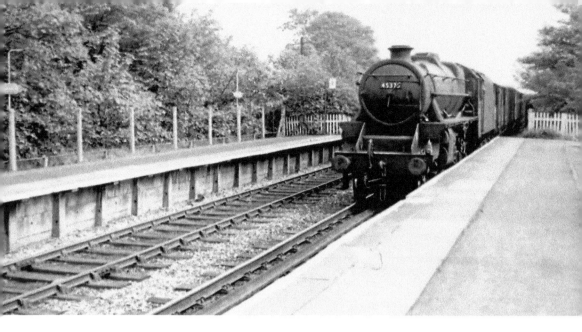

North Liverpool Line

The North Liverpool line, extending from Hunts Cross via Walton to Sandhills and Aintree, created further opportunities for the CLC. A goods train headed by Class 5, No. 45376 rumbles through Gateacre Station on its way to Huskisson Goods Station at Sandhills. On the left, the track is laid with bullnose rails attached to the sleepers through a chair and wooden block but on the right has been superseded by flat-bottomed rails clipped straight to the sleepers. It appears there are spare rails on the right to re-lay the left-hand track, but their life would be short as the line was closed thirteen years later. Gateacre Station has disappeared, but further down the line at West Derby a fine example of 'Domestic Architecture' has survived with a station over the line suited to cuttings. Provision for widening to four tracks was ambitiously incorporated into the construction as it facilitated the extension of the Bootle Goods Branch line with the possibility of more traffic still.

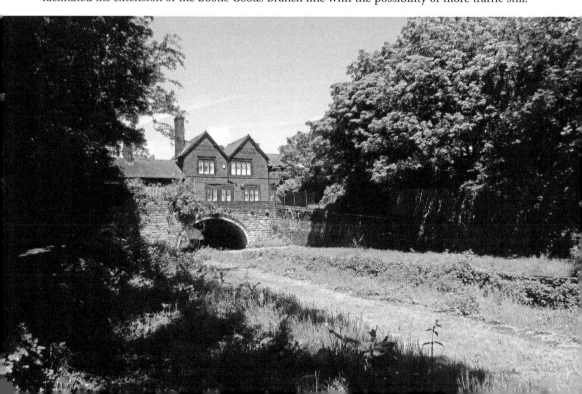

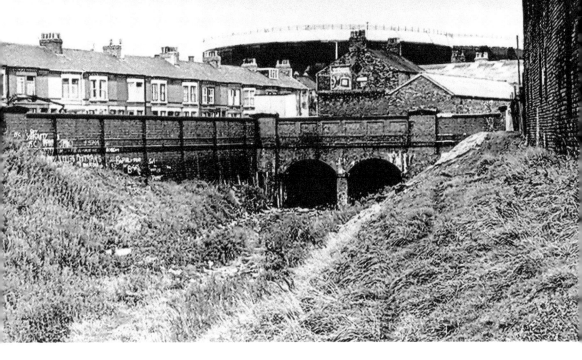

Bootle Goods Branch Line

The Midland Railway's Bootle Goods Branch line was constructed in 1885 to tap into the lucrative goods traffic at the Alexandra and Langton docks in competition with the LYR and the LNWR who already had connections there. The Midland's line connected with their main line system via a junction with the Cheshire Lines Railway (in which they had an interest) at Fazakerley Junction. The entrance to the tunnel known as the Ralla or Half Miley (actually 484 yards) started underneath Hawthorne Road, shown here with the gas works behind it and Aintree Road off to the left. The line was closed in 1968, the track lifted in 1969, and the tunnel mouth boarded up. Now, viewed from above the entrance, nature has taken over.

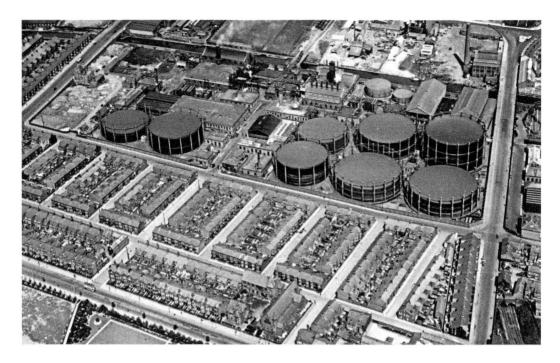

The Half Miley or Ralla

The railway to Alexandra Dock can be glimpsed entering the 'Half Miley' tunnel top right corner. Two bores, not one, were used to minimize the clearance as it burrowed underneath the canal (*top right*). It then followed the line of Marsh Lane by the cut-and-cover method, emerging bottom right. Although the cutting after that has been filled in and developed for a supermarket, the abutment remains (*below*). At the top centre can be seen a siding serving the gas works.

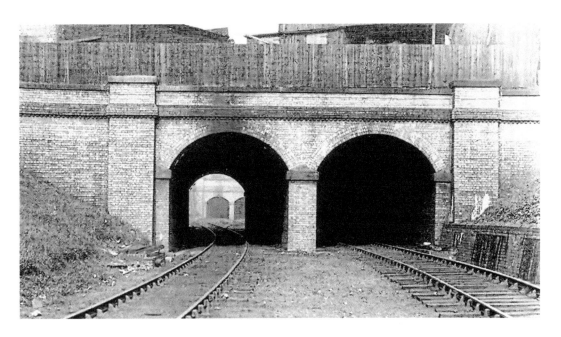

The Ralla or Half Miley

After emerging from under Marsh Lane on the west side of Litherland Road as seen in the distance of the photograph, the Bootle Goods Branch passed under Stanley Road (in the foreground). The line then burrowed under Marsh Lane and Strand Road Station, and the bridge has been preserved to provide an entrance to another supermarket. For some years after closure, it had been enjoyed as an unofficial adventure children's playground. From this point, the line was within easy reach of achieving its goal: linking up with the docks railway system.

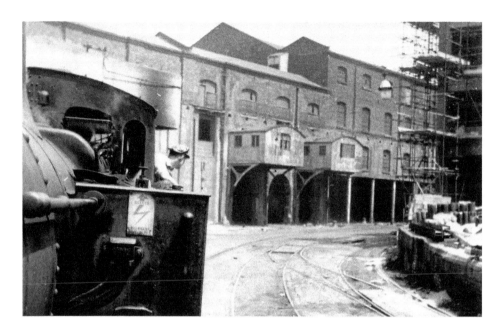

Midland Railway Goods

A view from the running board of Jinty No. 47487 at Waterloo Goods Station in 1964 illustrates the run-down state typical of freight provision at that time. At the end of its Bootle extension, the Midland Railway built a huge warehouse at Sandon Dock, but it also needed another distribution point in the centre of the city near to Central Station. The architect made a virtue out of an awkward curving site, which resulted in a most pleasing design and, advertising itself as the 'Midland Railway Goods Office', is described by Charles Reilly Professor of Architecture as one of the best buildings in the town. Its great doorways especially combine dignity with utility, and the building is now appropriately used as a 'Conservation Centre' by the National Galleries and Museums of Merseyside.

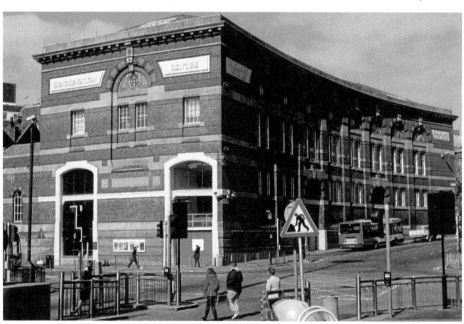

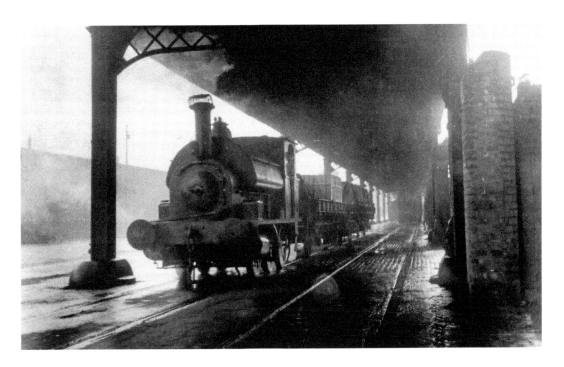

Dock Railway System

At one point, the Mersey Docks and Harbour Board railway totalled 104 miles (166 km) of line. Under the 'Dockers' Umbrella', as the Overhead Railway was dubbed, an unidentified 'Avonside' 0-6-0 (see pages 68–69) pulls a mixed goods train with spark arrester clearly visible. The arrester was needed because of the huge amount of timber imports through which the locomotives had to run. Remnants of the dock railway system that ran underneath the Overhead still exist, here with a branch leading off to the Huskisson dock. The inset at the Alexandra Dock shows one of the many lines that used to cross the dock road.

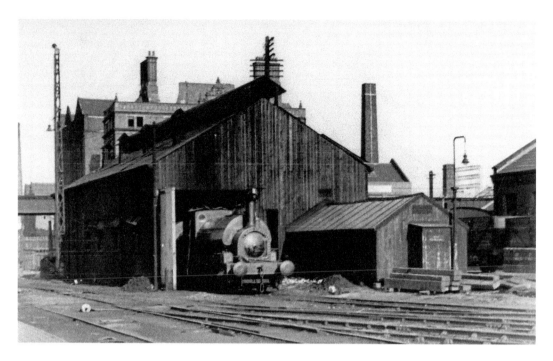

Avonsides

The Avonside Engine Company at Bristol designed engines with a short wheelbase for working on dock railway systems. Their locomotives were favoured by the Mersey Docks and Harbour Board and here 'Avonside' No. 29 peeps out from its shed at Canada Docks. The spark arrester can clearly be seen. Another characteristic feature was the safety valve fitted to the top of the dome, displayed by No. 26 now preserved at the Ribble Steam Museum in Preston.

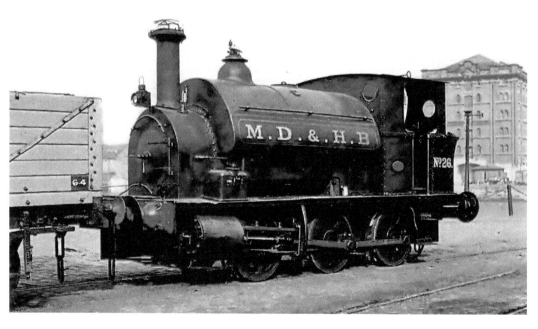

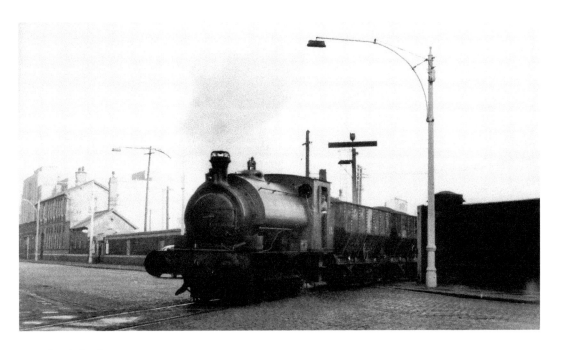

Dock Engines

A typical, varied, day's work for a dock engine is pictured above and below. *Above*, a mineral or coal train – maybe empties to receive imports – headed by an Avonside is emerging from one of the main line warehouses to cross the dock road. It may then (*below*) proceed under the Overhead Railway to the appropriate dock as illustrated by the picture below with an inside cylinder Hunslet 0-6-0 No. 31. The cargo this time might be perishable goods. This engine is not fitted with a baffle plate, so the effect of the sulphurous exhausts that were to be the downfall of the Overhead Railway can easily be imagined.

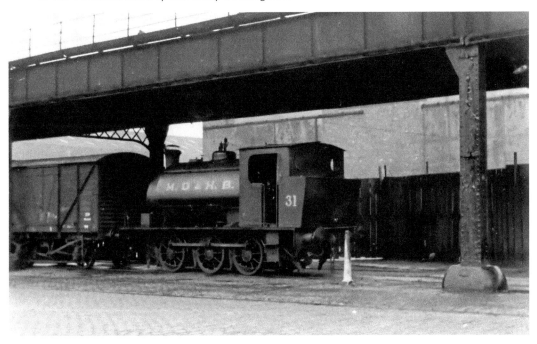

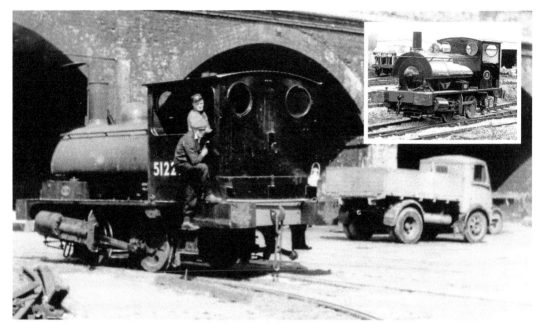

Pugs

Because of the extremely tight curves and light loads on the dock railway system, an even smaller engine than the Avonside with a shorter wheelbase was needed. The 'Pugs', as they were affectionately known, were specially designed by the LYR for working on the docks. *Above*, a 'Pug' is at work still sporting its baffle plate, intended to keep its polluting exhaust off the Overhead Railway decking, years after the Overhead had closed. The inset shows a Pug preserved at the Ribble Steam Railway. The dock lines linked up with the British Railways system. The mainstay shunting locomotive there was the Class 8 diesel shunter. One of these, the most numerous classes – nearly 1000 – of locomotives run on British Railways is pictured in Crown Street goods yard with driver and a visiting Danish railway enthusiast.

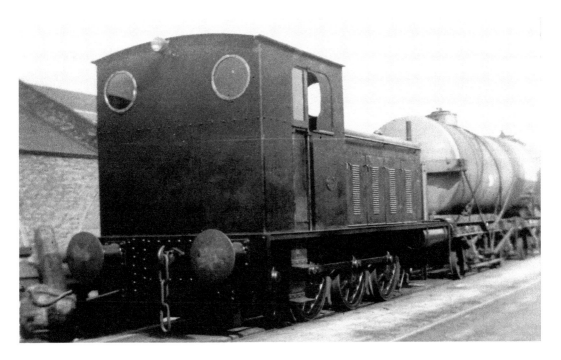

Diesel Dock Shunters

In 1998, the Merseyside Development Corporation created a diesel shunter modelled on the locomotives that used to roam on the dock railway system (*above*). Rusting, lonely and forlorn, it stands on the corner of Derby Road and Bankfield Street commemorating the completion of Atlantic Avenue, which replaced the Dock Road (and the Overhead Railway) as the main route along the docks into Liverpool. Brickwork represents sleepers, rails and a turntable leading into an imaginary shed, while iron vignettes record scenes of the old working Liverpool. *Inset*: track and shed at the Albert Dock.

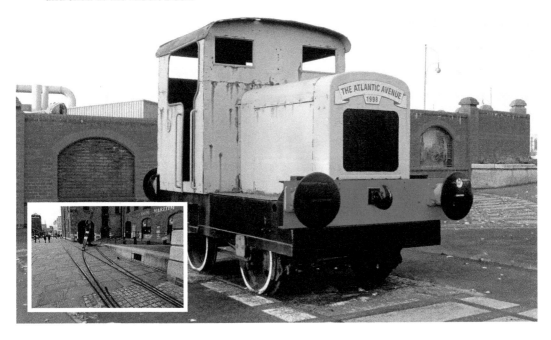

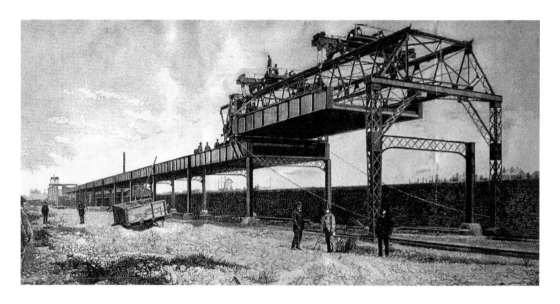

Overhead Railway Construction

Increasingly through the nineteenth century, there were problems for dockers wishing to travel from one end of the dock system to the other because of the growth of the dock goods traffic operating on the level between. The only solution was an Overhead Railway. A remarkable invention speeded up its construction from 1889 until its opening in 1893. A moving gantry, supported at one end on existing track, was moved forward on to a temporary support ahead of the completed decking. The new prefabricated section of decking was then raised into position, and the gantry moved forward on the track just created to lay the new section. When the railway was dismantled, the structure was sold for scrap. Only the columns embedded in the wall of the Wapping warehouse have survived as it was too much trouble to prise them out.

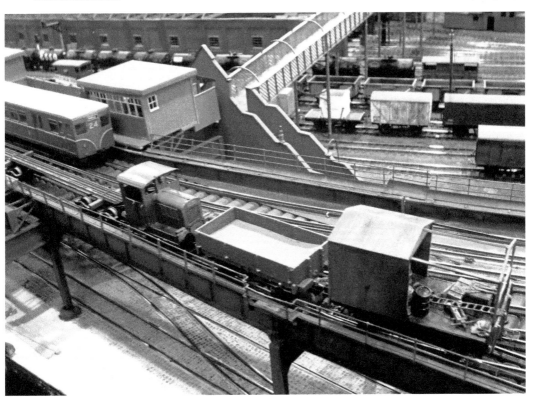

Overhead Railway Poster

The colourful array of funnels and spectacular views of the docks and beyond advertise the unrivalled interest of a journey on the Overhead Railway. Ships of Cunard, Canadian Pacific, Blue Funnel Line and many others proclaim the glamour of faraway places; cranes unload goods coming from all parts of the globe; New Brighton's alluring silhouette across the Mersey beckons with its leisure attractions. There is much for the railway enthusiast too particularly at the Herculaneum end, well illustrated by a view of a model railway layout with Brunswick Dock Station, goods yard and locomotive shed.

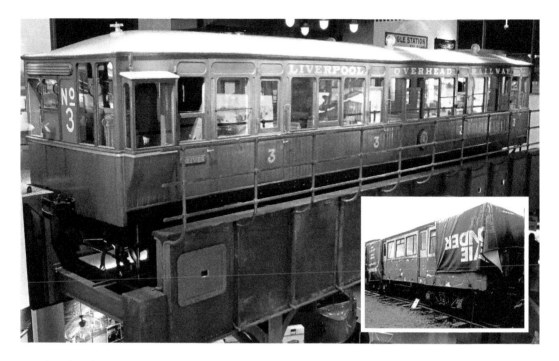

Overhead Railway Carriages

One of the original Overhead Railway driving cars has been preserved and beautifully restored, now on view on top of a replica section of track in the Museum of Liverpool. From 1947, some sets were modernised to include leather instead of wooden seats, power-operated instead of slam doors and a streamlined 'cat's whisker' front. The inset shows a modernised carriage awaiting restoration at the Coventry Electric Railway Museum. *Below*, is the wooden seated interior of the Museum of Liverpool carriage with realistic dummy passengers and a guard.

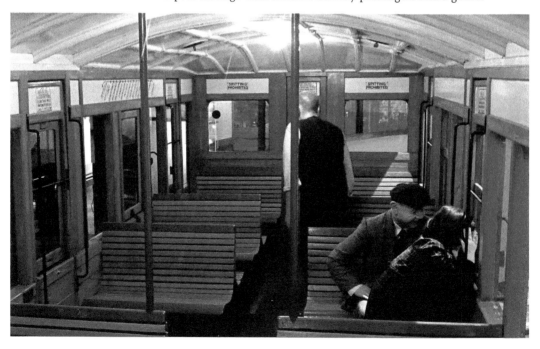

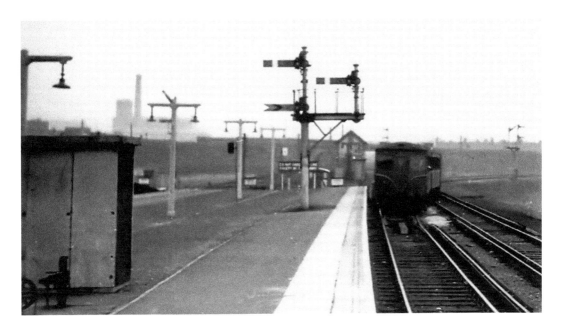

Seaforth and Litherland Stations

An Overhead Railway three-car unit approaches Seaforth and Litherland Station at the northern end of the line. The unit has been modernised, as can be seen by its streamline cat's whisker decoration on the front and obeys the signal to cross from the up to the down line to come into the platform. The right-hand signal on the gantry on the platform will then be raised by the signalman in the box ahead, and the train will start its return journey a few minutes later. The bridge over the railway ahead carries the Seaforth Connecting line. This ran from the North Mersey branch (from the left) to the Liverpool Southport line at Marsh Lane junction ahead. The signal on the left, a photographic 'sprouter', is in fact the starting signal for a Southport to Liverpool train at a platform on the far left.

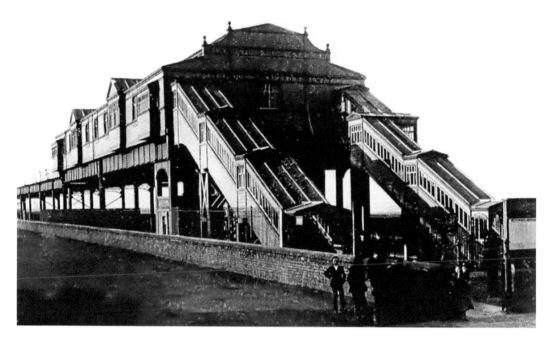

Seaforth Sands First Station

The Overhead originally terminated at Alexandra Dock, but a year later, it was extended to Seaforth Sands. Seen here in its original state, it had not yet acquired its escalator – only the second in the country – installed in 1901. Within a few years, however, the escalator was removed largely because of impending claims from women whose skirts had become entangled in the exposed machinery. When the line was extended to Seaforth, a bridge was built across the main Crosby to Liverpool road (*below*), a new station was built (visible to the left just beyond the bridge) and the old one converted to carriage sheds. It was a bottleneck for traffic and demolished when the Overhead closed. Its abutments were then replaced by a decorated brick wall (*inset*).

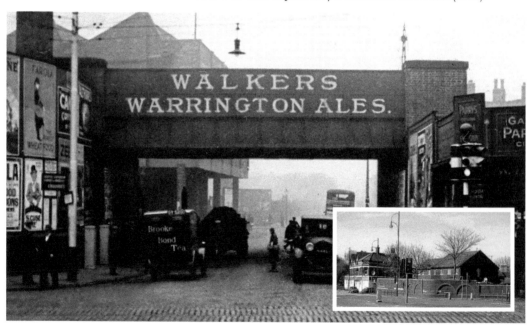

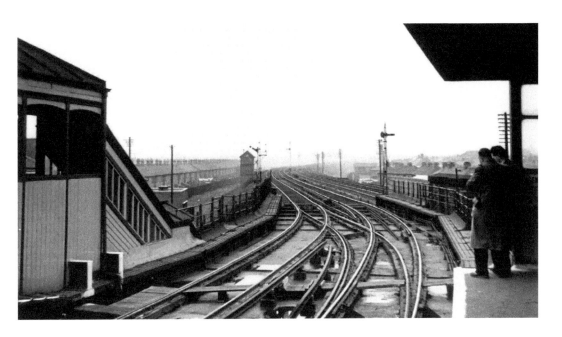

Seaforth Sands Second Station

We are looking from the second Seaforth Sands Station along the extension to Seaforth and Litherland Station to join up with the Liverpool to Southport line. The girders of the bridge across the main road can be seen straight ahead. The new line was built alongside the North Mersey branch of the LYR, which appears to the right of the photograph. A junction just beyond the signal box enabled Overhead trains to run to Aintree via the Fazakerley and North Mersey Branch of the LYR. After demolition of the bridges of both lines, the new brick wall replacing the abutments portray an imaginary railway station, a three-coach Overhead Railway train and a goods train that ran on the tracks beneath it.

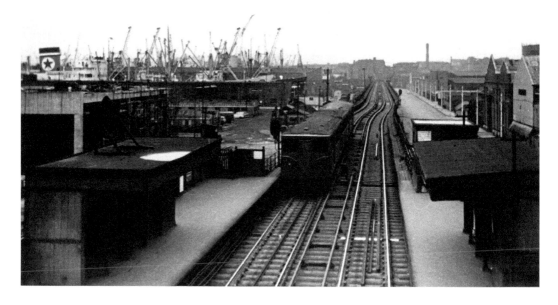

Huskisson Dock North

A train leaves Huskisson Dock Station named after Huskisson, who died at the opening of the Liverpool and Manchester Railway. It is heading north towards the forest of cranes servicing the Huskisson and Canada docks, which specialised in timber imports. Underneath the Overhead runs the dock rail system connecting the docks and facilitating transfer of freight between them. Now the cranes have gone, but the impressive walls and gates that Jesse Hartley built to safeguard goods in the dock area remain. They incorporate two blocked up doorways that once led to a station platform, which lay inside the dock estate. To keep the dock estate secure, a footbridge was built connecting with the other platform on the far side from which the archive photograph was taken. The inset shows the bridge that carried the Coal Branch (leading to the Bramley Moore coal drops) over the Dock Road nearby with a Pug showing its baffle plate in silhouette. Note the mechanism for the lift bridge over the road (fixed in 1940).

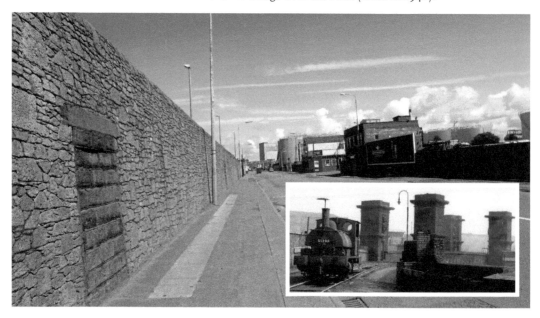

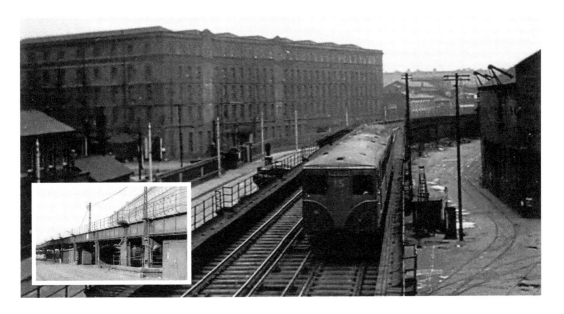

Huskisson Dock South

A train arrives at Huskisson Station from the south. The building on the left is the Sandon and Canada Docks Goods Station of the Midland Railway. A spur ran off to the left between the warehouses connecting with the CLC main line network via the Huskisson Goods Station (now an industrial estate by Sandhills Lane). On the right the dock connecting line emerges from below the Overhead to run alongside it because around the corner the Overhead line had to dip to road level to avoid clashing with the high-level coal branch of the LYR (*inset*: view of incline looking other way with Midland warehouse on right). This was an offshoot from their North Docks Branch, which diverged from their main line at Sandhills Station. The remains of the bridge carrying the line over Sandhills Lane can still be seen by the station as shown and also the abutment of the Coal Branch bridge on Regent Road (*inset*).

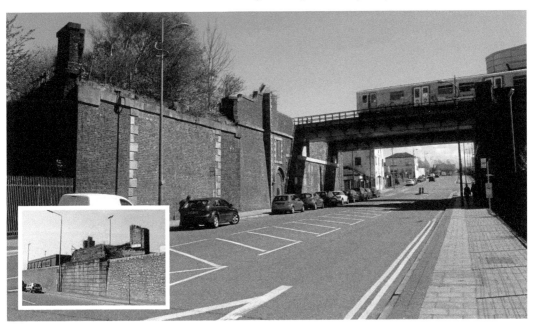

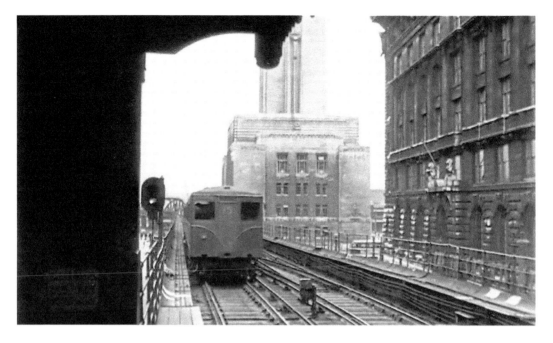

Pier Head Station Open

A southbound train leaves Pier Head Station. Passengers will have just enjoyed a first-class view of the Liver Building, and now on the right, the train is passing the Cunard Building. The Mersey Docks and Harbour Board building, third of the so-called 'Three Graces', will come into view in a moment beyond. The towering ventilation building for the Mersey road tunnel dwarfs a bus that will shortly go under the bowstring bridge glimpsed ahead at the end of James Street beyond which is its Overhead Station (there was also a station of the same name belonging to the under-river Mersey Railway). A modern watercolour gives an impression looking the other way from James Street of a view dating before the ventilation building for the Mersey road tunnel (1934) with a good view of the Goree warehouses destroyed during the Second World War.

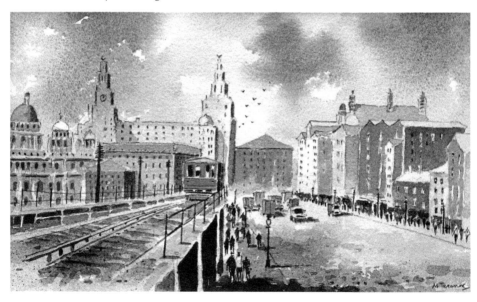

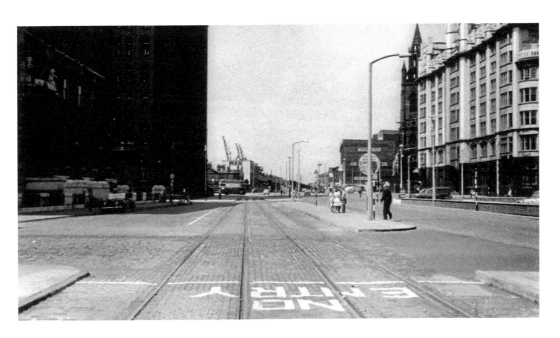

Pier Head Station Closed

Pier Head and James Street stations together formed the hub of the Overhead Railway. The Pier Head Station sported the Cabin selling souvenirs and fast food, while the Kiosk sold snacks and cigarettes. Trams passed by to and from the Pierhead terminus, which was only a short walk away, and from the Pier Head itself, ferries crossed the Mersey or the Irish Sea and liners crossed the Atlantic. A quicker way underneath the Mersey was afforded by a two-minute walk from James Street (Overhead) to James Street (Mersey Railway). The dock railway system that ran underneath the Overhead is still in place in a 1960 photograph, the only rail link between the north and south docks, but the Overhead had been dismantled late 1957. *Below*, the scene now.

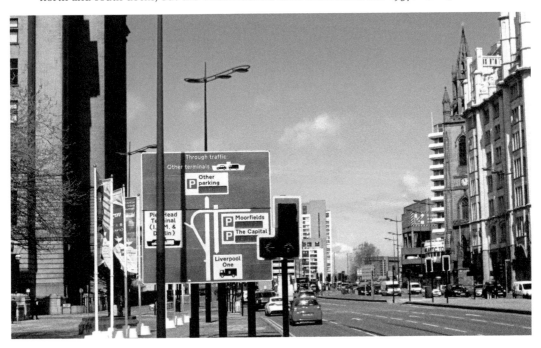

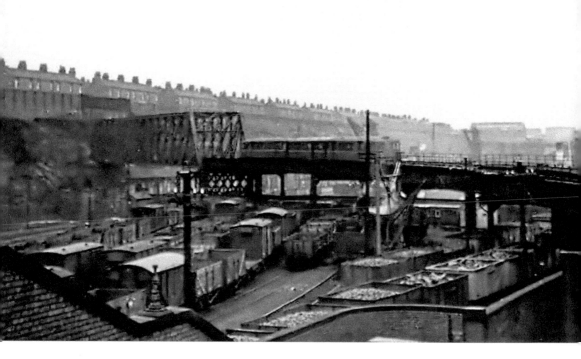

Overhead at Herculaneum

At the southern end of the line, the Overhead crossed the Herculaneum goods yard of the Cheshire Lines Railway and plunged into a tunnel leading to the Dingle terminus. As at the northern end, this was an extension of the line in 1896 to entice commuters and day trippers in addition to dock workers. A model railway layout set in the 1950s recreates the same scene. Brunswick engine shed is on the left, and Herculaneum Station and dock are on the right.

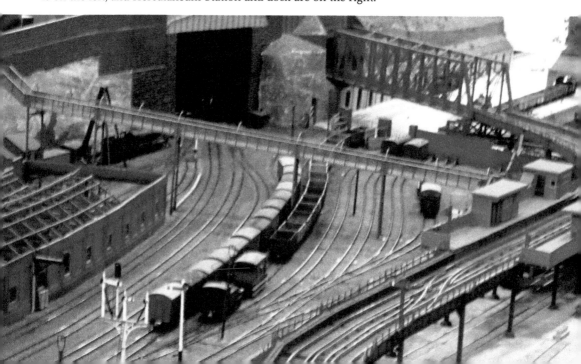

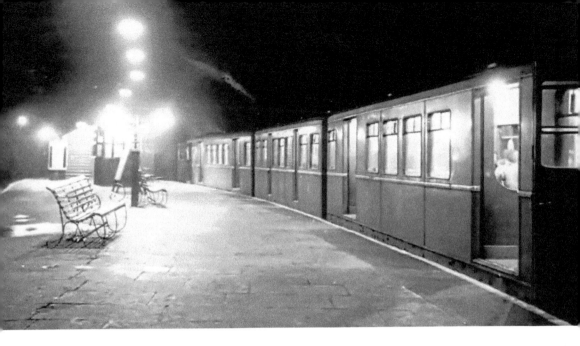

Overhead Underground

Dingle Station made a dark, grim and inhospitable end to an exciting journey. Six people were killed there in 1901 as a result of an electrical fire caused by arcing in a train that had been battling against a storm. To this day, the magnificent portal to the tunnel proclaims the names of the engineers headed by Sir Douglas Fox and Sir William Bower Forwood (chairman) and the contractors. The clearance between it and the roof of the Cheshire Lines tunnel was only 18 inches, which called for fine judgement and delicate construction.

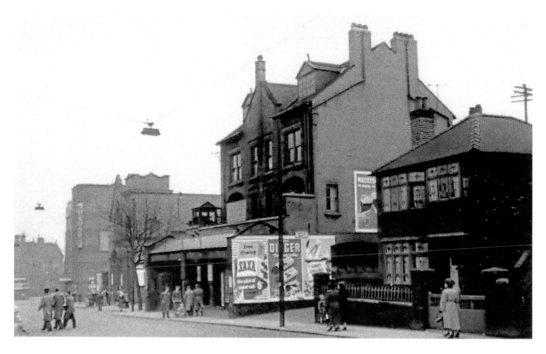

Dingle Station

Emerging from the southern terminus, you discovered that it was strategically situated in a residential and shopping area with church and cinema adjacent. Today, the church has gone, the cinema is deteriorating and the station premises have been converted into a car service station but house No. 426 survives intact and the tree has grown! The tunnel is used for storage although damaged by fire and the collapse of a section near the station, which precipitated the evacuation of a number of homes.

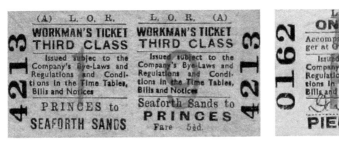

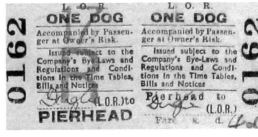

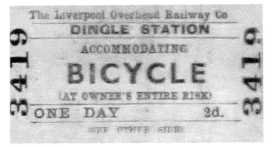

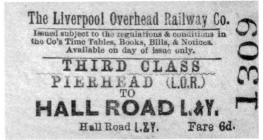

Overhead Railway Tickets

An unusual but most effective system was devised by the Overhead Railway to speed up the checking of tickets. Each station was allocated a number, which was printed large to indicate the destination of the traveller, numbering 1–17 from the Seaforth end, including dogs. The numbers could be read at a glance by the ticket collector. Note dogs travel at owner's risk but bicycles left for the day are at owner's entire risk! Tickets to stations on other lines could not be numbered in this way. Such tickets are shown with indications of the date of ownership of the other railways as they change through time: to Hall Road ('L.&Y.', i.e. Lancashire and Yorkshire Railway before the grouping of 1923), excursion to Southport ('LMS', i.e. London, Midland and Scottish Railway 1923–1948) and cheap day ('LMR', i.e. London Midland Region [of British Railways] 1948 onwards).

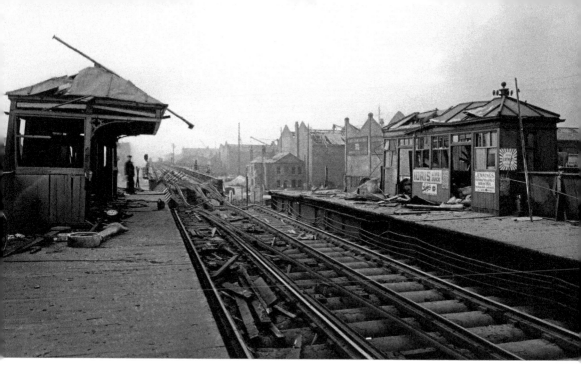

Overhead Railway at War

The Overhead Railway sustained much damage during the Second World War as here at Canada Dock Station. Two spans were destroyed by the bomb, but repairs as always were carried out quickly as it was so vital for the smooth running of the port. Thus, the import of vital supplies of food for the survival of the nation was ensured, as pictured below in the same location during the peace that it ensured.

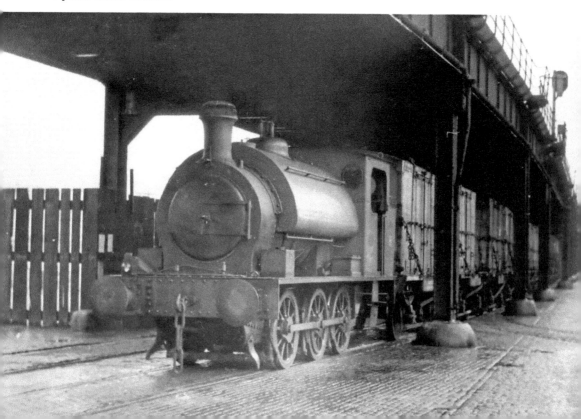

Overhead Railway Closure

In 1956, inspection of the line revealed serious corrosion in the decking caused above all by the sulphurous exhausts from the dock locomotives working underneath. No finance was forthcoming for the hugely expensive replacement by a company that barely ran at a profit. The last train ran at the end of 1956, and demolition started soon afterwards helped by a quaint 0-4-0 locomotive, dating from 1893 and aided by a dustbin, in the employ of George Cohen demolition contractors. It subsequently had a distinguished career in connection with the film *The Railway Children* and is now on static display at Ingrow on the Keighley and Worth Valley Railway.

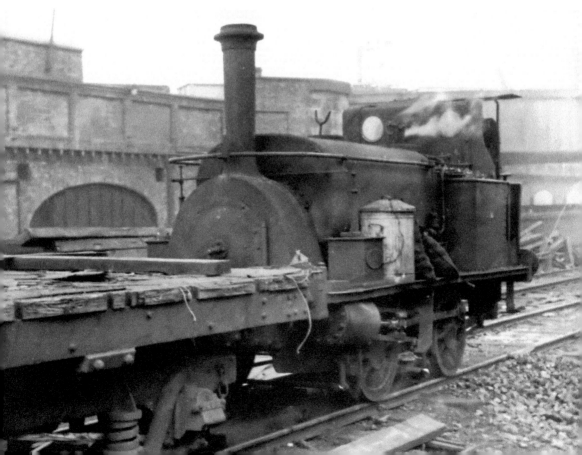

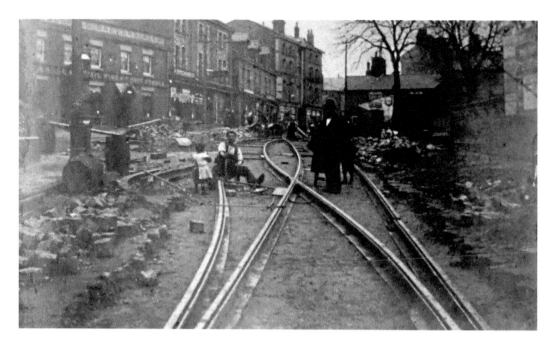

Overhead Railway Tramway

A little girl, clutching, hopefully, a doll – not a baby – gazes in awe at the navvy resting from his labours. The rails being laid among the sets are for the Overhead Railway's tram extension from their terminus at Seaforth Sands to Crosby. It was single track with passing loops as shown here in Liverpool Road, Crosby, which at the time was described in a guide book as 'a picturesque old village'. *Below*, the first 'electric car' travels through the village on 20 August 1900.

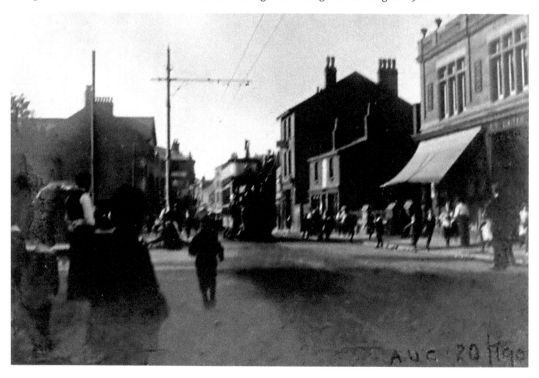

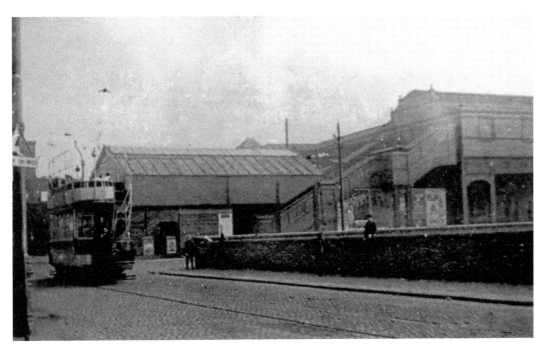

Overhead Railway Tramway Closes

The Overhead Railway advertised as far away as Ireland encouraging its visitors to come and travel on its line, which would afford 'a panoramic view of 6.5 miles of the finest docks and shipping in the world'. They could then enjoy the sands of Seaforth and travel from Seaforth Sands Station to enjoy the delights of Crosby village. But the tramway was closed in 1926 when the lease ran out and bus services took over. The only trace left is half a tram post that used to support the electric wires in Liverpool Road, Crosby, opposite St Peter and St Paul's Church.

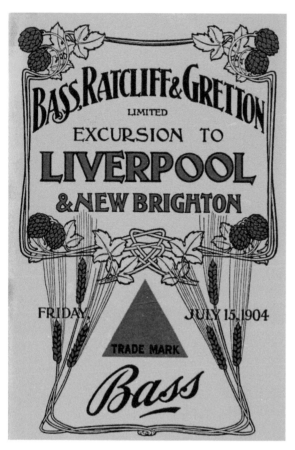

Bass Excursion
The cover of the 1904 brochure of a works excursion to Liverpool from Burton upon Trent extends to ninety-six pages. Seventeen trains converged on the confined quarters of Central Station within the space of three hours. From there, one-day, weekend or whole-week excursions were arranged to visit such varied places of interest as the Walker Art Gallery, the landing stage, the New Brighton Tower and Llandudno, via varied forms of transport such as tram, the Overhead and Mersey Railways, ferry across the Mersey and boat to the Isle of Man. *Below*, is the Overhead Railway fare list that used to be on display outside Dingle Station.

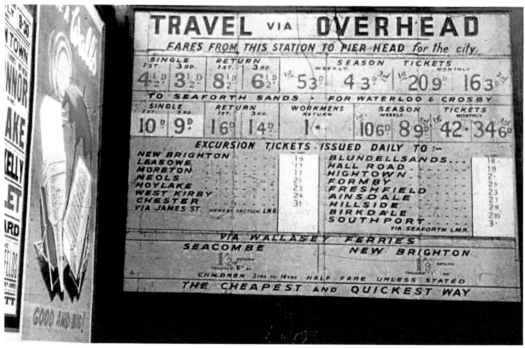

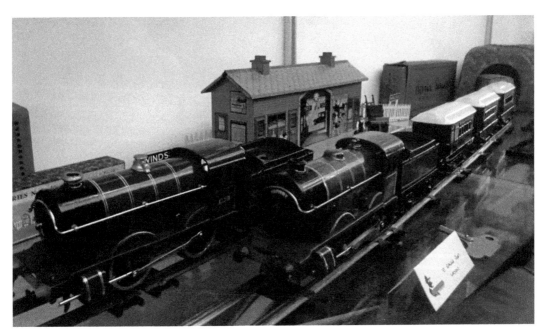

Hornby Model Trains

There was a time when every boy's dream was to own a Hornby model train. *Above*, the locomotive on the left, on display in Meadows Leisure Centre and Library in Maghull, is modelled on the distinctive Great Western Railway (GWR) style with copper band around the chimney and matching safety valve and water feed. On the right is a locomotive with the green livery and rounded boiler of the London and North Eastern Railway (LNER) drawing brown and cream Pullman coaches such as the Harrogate Pullman. Frank Hornby, who lived in Maghull on the outskirts of Liverpool (house pictured below with blue plaque), built up an empire based on Meccano and model trains, manufactured in Liverpool. The Hornby brand is still strong (see fine inset models of GWR and LNER locomotives).

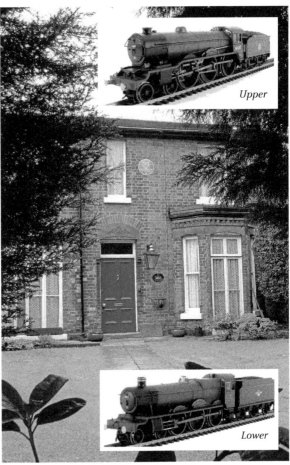

Upper

Lower

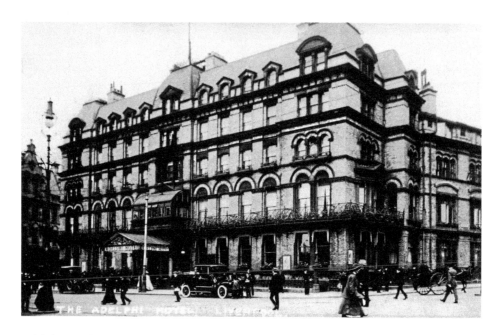

Adelphi Hotel

The Midland railway acquired the old, second, Adelphi Hotel in 1892, renaming it the Midland Adelphi. Royalty and Charles Dickens chose to stay there en route to the United States. It was demolished in 1910 to be replaced in grand transatlantic style and opulence to compete with other grand railway hotels owned by its rivals at Lime Street and Exchange stations. It was only two to three minutes of walk from Central Station to which the Midland ran through non-stop trains from London to promote business. The luxurious accommodation was aimed at American travellers, and the Sefton suite (as illustrated) is a replica of the First-Class Smoking Lounge of the Titanic.

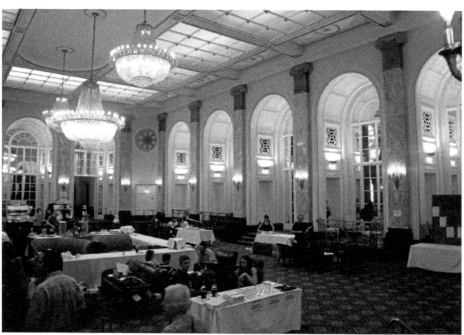

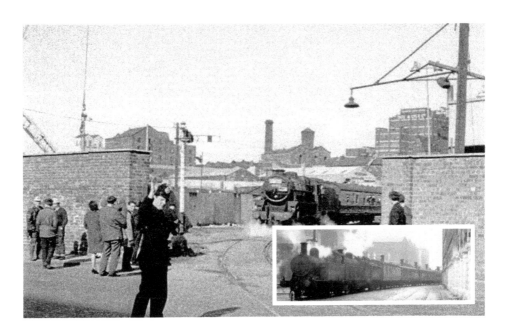

Waterloo Goods Station

There was a time when a train like this would be preceded by a man carrying a flag. However, this 1968 special headed by Class 5, No. 45305 recreating a boat train journey to Riverside Station is only safeguarded by a signal at danger, which will bring it to a stop and by a policeman holding up the traffic as it prepares to cross the Dock Road. It is emerging from the remnants of Waterloo Goods Station, the terminus of a goods extension from Edge Hill, to a depot on Waterloo Road by Waterloo Dock in 1849. This was achieved by a formidable tunnelling operation involving the construction of two tunnels totalling over two miles in length. The portal of the first one, Victoria Tunnel, is shown in the main picture below which led to a 'lung' of seventy yards before the second, Waterloo, leading to the goods depot. The inset shows a boat train with Jinty No. 47404 piloting o-8-o goods No. 49437 crossing the dock road the other way in 1958 with the Waterloo warehouse on the right. Some Overhead Railway girders are still in place.

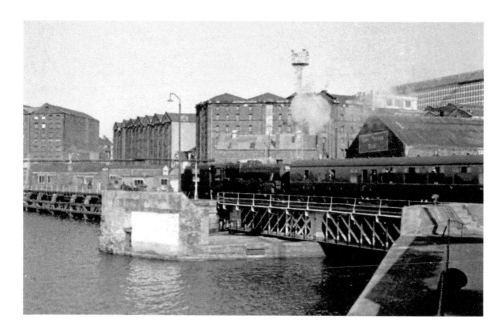

Princes Dock Swing Bridge

The extension from the Waterloo Goods Station to Riverside Station was created in 1895 by an ingenious arrangement. After crossing the dock road (at this point Waterloo Road), it travelled over a swing bridge between the two halves of Princes Dock to terminate at the Landing Stage by the Pier Head. It was in use for boat trains only until 1971, except a special as here in 1968. The progress of the trains into Riverside can be traced on the aerial view. Waterloo Goods Station is now the retail park (*centre right*). After crossing the dock road, they skirted the Waterloo warehouse, still there but converted into apartments. They then passed over the swing bridge (hidden between the tower blocks) and disappeared off scene centre left. The Overhead Railway followed the dock road bottom left to top right into the distance. Although the bridge has been demolished, the abutment survives (*inset below*).

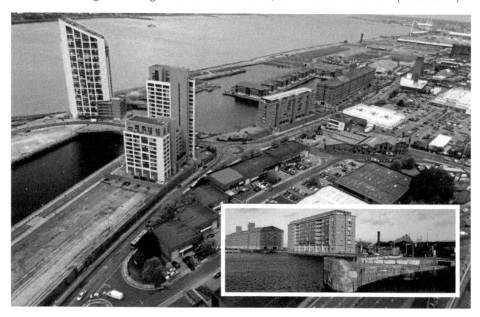

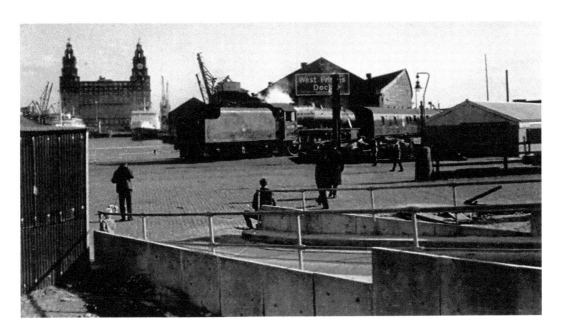

Riverside Station Approach

Once over the swing bridge, the tracks fanned out on the approach to Riverside Station. On one of these, a special train in 1968 with the waterfront Liver Building in view in the distance makes slow regulation pace towards the swing bridge. In the aerial view Riverside Station has been replaced by the Cruise Terminal and Princes Dock Offices on the centre right. On the approach to the site of the station, some tracks have been preserved among the cobbles with seats where visitors may rest and imagine the interest of bygone days when trains might be preceded by a man with a red flag at no more than 4 mph. In the inset, the Waterloo warehouse is in the distance to the right of the lifebuoy with the site of the Waterloo Goods Station just over the road beyond.

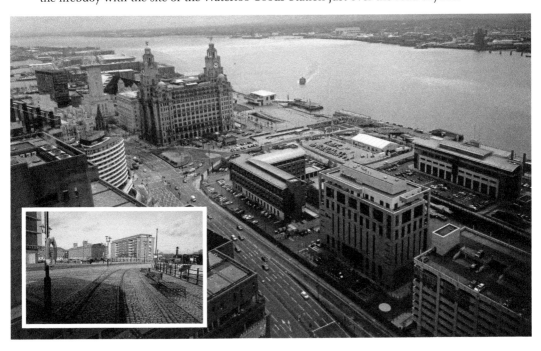

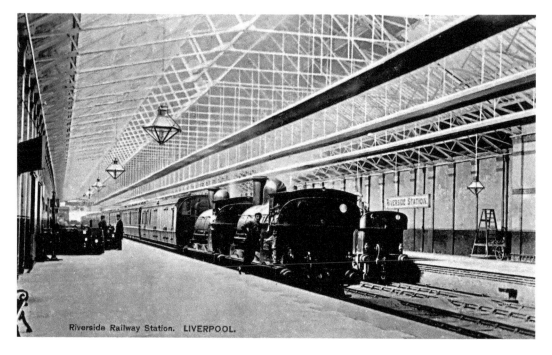

Riverside Railway Station. LIVERPOOL.

Riverside Station

A train has arrived at Riverside Station when Liverpool was the main port for transatlantic traffic. Until 1895, First-Class passengers had to use the Adelphi Hotel as a transition stay or make the awkward journey from Lime Street Station. During the Second World War, 1.7 million troops passed through the station and a further three million through the docks. As late as May 1951, it hosted two royal trains when Queen Elizabeth arrived on her way to Northern Ireland and Princess Margaret joined her in another train. A recent royal occasion, celebrating the 175th anniversary of the Cunard Line, saw the arrival of Queen Victoria and Queen Mary (2) when the site of Riverside Station was also graced by another Queen Elizabeth.